The FAITH of AMERICA

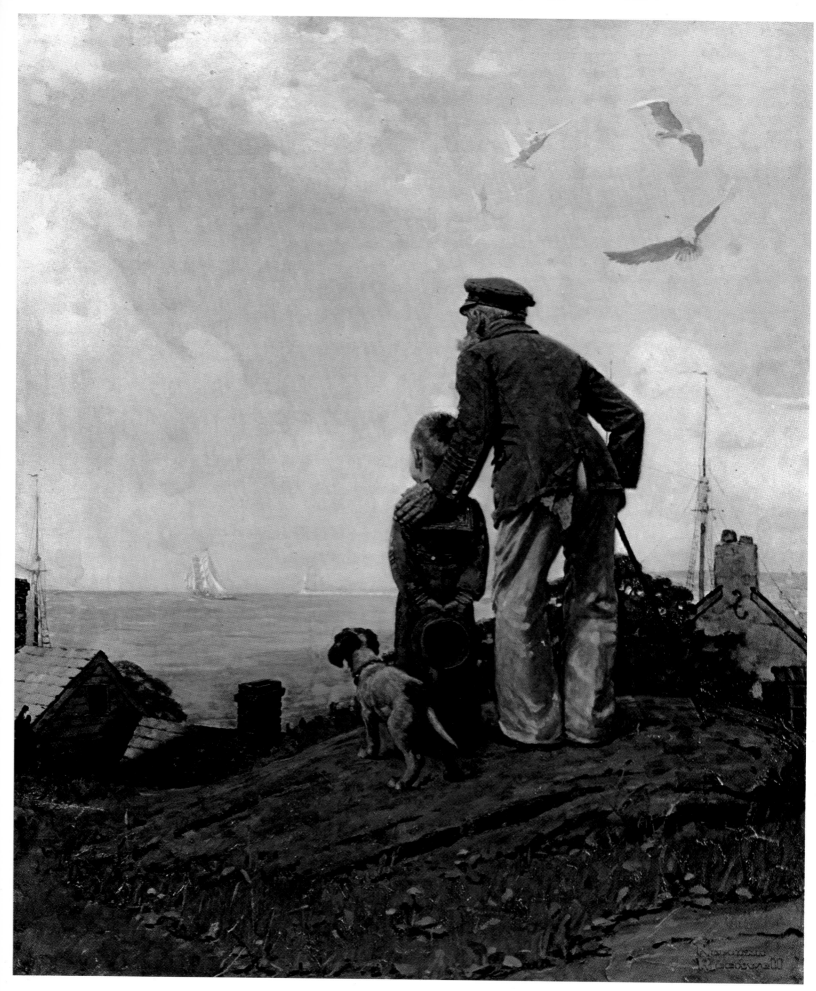

Looking Out to Sea, 1919

The FAITH of AMERICA

ILLUSTRATED BY

Norman Rockwell

TEXT BY FRED BAUER

ABBEVILLE PRESS PUBLISHERS NEW YORK

Grateful acknowledgment is made to the following for permission to reproduce the illustrations listed on the pages below:

Aerospace Museum, The Smithsonian Institution, Washington, D.C.: p. 80. Boy Scouts of America, North Brunswick, N.J.: pp. 23, 112, 154. Produced from art from the Archives of Brown and Bigelow, Inc. and by permission of the Boy Scouts of America. Cordelia B. Comar: p. 24. Mr. and Mrs. Phil Grace: p. 151. Mrs. Arthur Guptill: p. 145. Norman Rockwell Estate: pp. 2, 11, 16–17, 20, 28, 139, 157. Old Corner House, Stockbridge, Mass.: pp. 19, 25, 38, 44–45, 62, 82–83, 110, 128, 158. Sheldon Memorial Art Gallery, University of Nebraska–Lincoln: pp. 108–109.

Library of Congress Cataloging-in-Publication Data
Bauer, Fred, 1934–
 The faith of America/illustrated by Norman Rockwell; text by Fred Bauer.
 p. cm.
 ISBN 0-89659-813-6
 1. Rockwell, Norman, 1894–1978—Themes, motives. 2. Painting, American—Themes, motives. 3. Painting, Modern—20th century—United States—Themes, motives. 4. Civil religion—United States. I. Rockwell, Norman, 1894–1978. II. Title.
ND237.R68B38 1988
759.13—dc19 88-3382
 CIP

A PROFILE:

Norman Rockwell

(1894–1978)

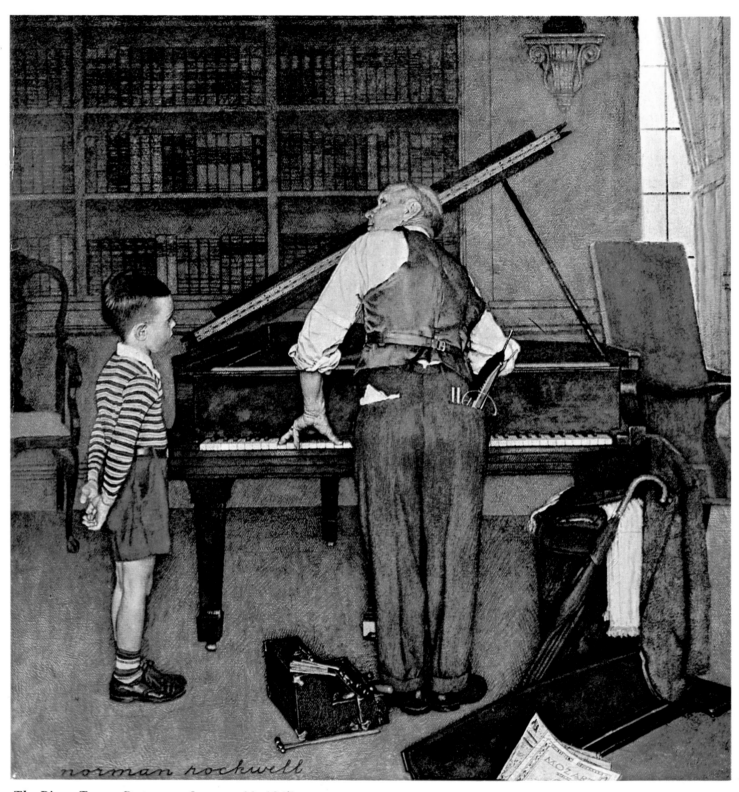

The Piano Tuner, *Post* cover, January 11, 1947

As I drive Route 7 toward Stockbridge, the bright early March sunshine pierces the bare Berkshire hills to their snowy-white scalps. That's what I see when I squint at the rolling landscape—the shapes of many heads. The denuded trees stand prickly and sparse on them like thinning hair. Taking my right hand away from the steering wheel, I touch a smooth spot on my temple that once was covered, and smile at the similarity.

Soon, I tell myself, the spring equinox will work its annual magic and these ageless mountains will come to life. I remember well the summer I walked them while hiking on the Appalachian Trail, which snakes its way along high ridges around Great Barrington, Stockbridge and Pittsfield on its way to Maine or Georgia, depending on the inclination of the pilgrim.

That summer I had descended into this lush valley carved out by mighty ancestral waters of the Housatonic to replenish an empty knapsack, and picturesque Stockbridge had provided me with both rations and a pleasant respite. Now I am coming back on a different mission: to find one of Stockbridge's most illustrious residents, Norman Rockwell. The problem is, I am late. Maybe too late, I fear. Four months earlier, America's most popular illustrator had died. Not unexpectedly—he had been failing, noticeably, for almost three years.

Molly Rockwell, nee Molly Punderson, had answered reporters' questions about the cause of her husband's death with a directness characteristic of New Englanders.

"He died," she said simply, "of being 84."

My contact with the Rockwells had been indirect until this visit. Several years earlier I had contacted Norman Rockwell in the hope of doing a book that would focus on some of his more inspirational illustrations, the ones that lifted spirits and filled doubting hearts with hope and faith. Though he had responded with a kind note, the project didn't materialize, languishing like a simmering stew on a back burner until one day in mid-1978 when my old proposal was revived. Through the efforts of the late Harry Abrams, the fine art book publisher and long-time Rockwell friend, the artist was recontacted and the project resurrected. Molly Rockwell wrote that she would indeed

be happy to arrange for me to interview Norman, "though I cannot promise how well he will be on any given day."

But, alas, our meeting did not take place. Rockwell's health declined further, and on November 8, 1978, he died. "Don't suppose you'll be doing your Rockwell book now," a friend suggested a few days later, and though I had momentarily wavered, I corrected him, responding that I figured the book I had wanted to write before the artist's death still had as much merit—maybe more—after it. So four months later in the spring, I journeyed about 200 miles north of my home in Princeton, New Jersey, to Stockbridge for the purpose of talking with the artist's widow, friends, and neighbors, hoping they could help me draw a retrospective picture of the man who for nearly sixty years had been America's best-known, best-loved illustrator.

After checking in at the historic Red Lion Inn, long a centerpiece of this quaint village, I phone Mrs. Rockwell to arrange our first meeting. From the window of my corner room, I look down South Street, half a block to the Rockwell house, an early 19th-century Colonial structure, white-framed with black shutters. The barn-red studio, a remodeled carriage house, is located behind the house, partially hidden from my view by evergreens.

"Hello," comes the cheery voice that answers after two rings. It is Molly Rockwell.

My dossier on Molly reads: Stockbridge native; Radcliffe graduate; English teacher 39 years, Milton Academy for Girls; retired 1959 and returned home to Stockbridge; married Norman Rockwell, October, 1961.

"Yes, come right over," she bubbles. A few minutes later I arrive at the back door—or north side door, really. Unlike another New Englander, I take the path that seems "more traveled," and in this case choose correctly.

Molly Rockwell opens the door and invites me in. "She's charming," everyone has told me, and she is. Though in her eighties, Molly's crisp voice, bright, responsive eyes and easy smile glide over the fact like a brook rushing over submerged stones.

While hanging up my coat in a closet, I notice workmen in the center hall. Ceiling leaks, Molly explains; damage revealed by winter's thaw.

"I'm sorry, I forgot the piano tuner was coming, too," she apologizes over the plinking of a piano. Leading me into the living room, she discusses the work to be done with a young man bent over an old light brown Steinway upright. (I recall a *Post* cover Rockwell did of a piano tuner being watched by a small boy, but that workman was tuning a grand piano, so this one wasn't his model.)

I ask some elementary questions about the art of tuning a piano, and the repairman gives me some elementary answers. Then I help him move the instrument away from the wall before Molly and I retire to the dining room, which she hopes will be quiet enough.

"Do you play?" I ask, nodding in the direction of the plinking.

"No, I'm not very musical."

"Did Norman?"

"No, but his children did. And some of his grandchildren. They're coming to visit, so I thought I'd have it tuned. Hasn't been tuned in 17 years that I know of." I make a mental note that that period covers their marriage. Rockwell came to Stockbridge in 1953; Mary, his wife of 29 years, died in 1959 and two years later he married Molly.

We make some more small talk (about cedar waxwings at her bird feeder: "You can take a few of them home with you—we've got too many"; and about her book *Willie Was Different*, the story of a skinny thrush, which Rockwell illustrated) before I begin describing the shape and direction of the book I have in mind, and my mission—to learn everything I can about the man behind the famous illustrations.

Molly's vivid blue eyes glow with love and admiration as she discusses the years she and Rockwell spent together. Adjectives such as *kind, considerate, gentle, warm, caring,* are either used or implied to describe her dear Norman.

I ask about their courtship and marriage. Following Mary's death, Norman's recovery from mourning was slow and painful. One day a doctor-friend told him that what he really needed was a wife.

"And who might that be?" responded Rockwell.

The doctor had an immediate suggestion: "How about Molly Punderson?" Rockwell didn't know her but the physician-matchmaker had planted a seed that was to grow.

Learning that Miss Punderson was teaching a once-a-week poetry class for adults, Norman enrolled—in the interest of learning more about Shelley, of course. According to Molly, Norman's wit enlivened the course no end. Once when there was a debate about the meaning of a Robert Frost quatrain, Rockwell said he would settle the question by calling his friend, Robert. Whereupon he left the classroom, ostensibly to call the famous poet.

When he returned in a few minutes Rockwell reported what he had gotten "straight from the horse's mouth." "It was a convincing performance," recalls Molly with a smile, "but a joke. Norman didn't know Frost, nor did he call him."

I ask about Rockwell's work schedule, reportedly backbreaking,

and Molly concurs that he was a "workaholic," forever taking on more assignments than he should have and then feeling the pressure of deadlines. ("A deadline is like a mean-tempered terrier," he once said. "It won't leave you alone for a moment. You run and hide behind a tree and after a while thinking you've escaped him, you step out and 'ruff,' he's got you by the heel.")

"He had enormous energy and enthusiasm for his work," Molly adds. "After breakfast each day, he would go to his studio and paint until 12:30 or 1 o'clock. Then he would lunch, take a nap, and then go back to work until dinner time. Only in the last three years did he alter his schedule appreciably."

"Is that when he began to fail?" I ask.

"Yes," Molly answers. "The first problem came when we were vacationing in the Caribbean three winters ago. One evening Norman went out on a bicycle by himself and didn't return when he'd said he would. As it was getting late, I went looking for him and found him alongside of the road. He'd lost his balance, fallen off the bike and couldn't get up.

"But he wouldn't give up bike riding. Whenever weather permitted, we rode almost five miles a day." (Rockwell, in an interview, once said that he and Molly cycled 4.7 miles daily on their course through Stockbridge—as precise a pedaler as he was a painter.) "Then Norman had another fall, and he had to give up bicycling."

"Did he continue to paint?"

"He tried, but it was difficult."

His last effort, she tells me, was an unfinished historical painting which is still on Rockwell's easel in the studio. "Could I see it?" I ask.

"Certainly," she responds.

Putting on our coats, we make the short journey to the studio behind the house. The footprintless snow and unbroken ice tell me the studio hasn't been entered for some time.

Inside, my eyes fall on the illustration Molly had described. It sits in the center of the studio, lit by bright sunlight from the high north windows, as if waiting for its creator to return. The setting of the painting is the interior of a Colonial home and it features three individuals: John Sergeant, the first missionary to the Stockbridge Indians, who built a home in Stockbridge in 1739—the year it was incorporated; an Indian student who sits oppostie him; and the minister's wife, Abigail, who is peeking in from the doorway. Ever the storyteller, Rockwell was reporting two pieces of historical information—the first, that Sergeant's prime business was to bring Christianity to the Indians; the second, a footnote: Sergeant's wife heartily disliked them.

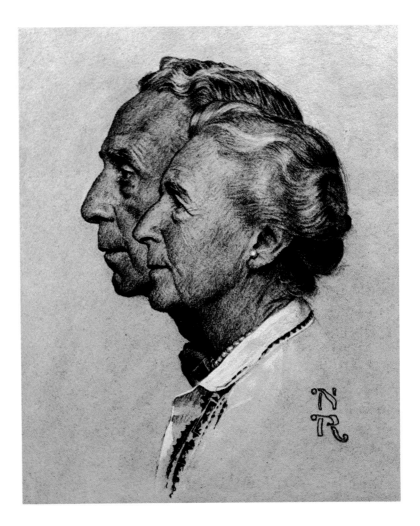

Molly and Norman Rockwell, 1965

After I have studied the painting, my gaze turns to the studio, neat and clean, about as Rockwell left it, I suspect. (He once said that the older he got, the more time he spent cleaning his studio and the less he painted. "In my last years," he predicted, "I may abandon painting all together and spend all my time 'neatening up.'") His brushes are still here. So are his paints and canvases, all the tools of his trade. On the walls are newspaper and magazine clippings and sketches and prints and framed awards.

All about are old props, many worn by his models. Looking at them I remember reading about the research Rockwell did for his *Tom Sawyer* and *Huckleberry Finn* illustrations. Not only did he go to Hannibal, Missouri, to get the flavor of Mark Twain's people and places, but he also bought old clothes off the backs of puzzled local residents to use on his models.

"I would lie in wait on Main Street [in Hannibal]," Rockwell once

recalled. "If a fellow came along in pants that had character, I'd ask him if he wanted to sell them. 'I'll give you five dollars for them.' I'd say. 'They aren't worth five dollars,' he'd reply. But I'd convince him, and we'd go over to the car, pull down the curtains and he'd take them off. The same with hats, shirts and so forth. In the meantime, I'd have to go into a shop and buy new things to take their places. Gradually, by purchase and barter I gathered the worn-out costumes I needed."

Rockwell went on to explain why he was so determined to get used clothes: "You can't make a straw hat look old by rubbing it in the dirt. It doesn't work because I've tried it. A hat has to be worn in the sun and sweated in and sat on and rained on." Such was the authentic detail demanded by Rockwell.

Also hanging in his studio are scores of souvenirs. "He never came home from a trip empty-handed," sighs Molly.

I make note of a Grandma Moses print, and Molly explains that Norman and the popular artist of primitive paintings were good friends. "I believe Norman included her in one of his paintings," I add. Molly nods that I am correct.

Then, we are both silent for a moment. The sound of my feet echoes through the room, reminding me that its resident is away. "Sometimes I came out here and kept him company while he worked," Molly volunteers. "He liked me to read to him." (Somewhere, I read that when Rockwell made the transition in the late thirties from mostly live models to working mostly with photographs, what he missed most was conversation with the models. As his work suggests, he really enjoyed people.)

Out the back window of the studio, I observe a wide expanse of meadow that meanders toward the Housatonic and vaguely recall a fragment of the autumnal salute once given it by a lover of the Berkshires, William Cullen Bryant: "I well remember, as I passed through Stockbridge, how much I was struck by the beauty of the smooth green meadows on the banks of that lovely river, the Housatonic, whose gently flowing waters seemed tinged with the gold and crimson of the trees that overhung them."

As I look over that gentle pastoral landscape, I wonder to myself how many times Rockwell had stood where I'm standing, seeking the inspiration that all people who create sometimes wait for. Rockwell had his share of dry spells. Though his prolific output may lead some to believe his paintings went on canvas like butter, I recall reading about the difficulty he had coming to terms with his famous *Family Tree.* (p. 15) and how he struggled for thirty-three days painting another classic, *The Marriage License* (p. 60).

Turning back to Molly, I walk past Rockwell's desk on which rests all sorts of odds and ends. The collection reminds me of the time I looked through my father's billfold a few days after his death. It contained a driver's license renewal notice, a reminder of an appointment, a birthday date card, a list of often-called phone numbers, membership cards—all those important papers of one's life that become so trivial after it's over.

"I must be going," I tell Molly and we move toward the door. She kindly suggests some other people I may want to see. I thank her for her hospitality.

Outside, in the bright sunlight, I ask if she is getting along all right.

"Oh, yes," she replies firmly. I'd have been surprised if she had answered any differently. Proud, strong, and independent, Molly Punderson Rockwell doesn't hail from complaining stock.

Taking her arm, I walk with her back to the house across melting ice that makes the path a glaze.

"Here comes spring," I say.

"I hope so," she answers.

"It's been too long a winter."

"Yes," Molly agrees quietly. "It's been a very long winter."

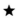

Walking along Stockbridge's old-fashioned Main Street, from west to east, I pass the Red Lion Inn (Molly Rockwell told me that her father had worked there as a manager), the bank, the grocery (above which Rockwell once had his studio) and the library on my way to the town's principal tourist attraction: the Old Corner House Museum. I've come for two reasons—to see the Rockwell originals on exhibit here and to interview David Wood, the museum director. First the illustrations.

Though I know from previous experience the tremendous difference there can be between an artist's original painting and a reproduction, I am not prepared for the impact of Rockwell's full-sized originals, bold in color, brushstrokes clearly visible. Looking at them an arm's distance away, five or six times larger than magazine reproductions, I see even more detail, more nuance, than before, and his work fills me with more awe than ever and with added admiration for his ability to dramatize scenes.

His four *Freedoms* enrapture me first off. Critics seem to give Rockwell's *Freedom of Religion* (p. 158) the highest marks of the four, but here I find *Freedom from Fear* (p. 62) and *Freedom of Speech* (p. 128) just as impressive, with *Freedom from Want* (p. 110) not far behind.

But there are other paintings in the exhibit that grip me as much. Call me a sentimentalist or a romantic, if you will, but there are certain pieces of music, certain stanzas of poetry and certain paintings that pull on my heartstrings, that bring a tear to my eye, that cause the hair on the back of my neck to rise; several of Rockwell's illustrations get to me in this way.

In other instances, studying Rockwell's originals in the museum brings not emotion but new insight or understanding. Take Rockwell's *Lincoln for the Defense* (p. 19), which depicts Abe as a young Illinois lawyer in a trial setting. The man in the background is his client, a manacled defendant. I had never noticed that the booklet Lincoln is holding in his hand is an almanac . . . but suddenly I understand. Rockwell is storytelling again—this time the legendary one about Lincoln disproving a witness's claim that a full moon had enabled him to see the defendant leave the murder scene. Lincoln got the man acquitted by turning to an almanac, which revealed there was not a full moon on the night in question.

There are many pleasant Rockwell staples here—including *Home for Christmas (Stockbridge Main Street at Christmas* (pp. 16–17), *War News* (p. 24), *Spring Flowers* (p. 20), *The Runaway* (p. 41), *Gilding the Eagle* (p. 141) and *Going and Coming* (p. 64)—but there are surprises, too.

I have not seen his *Son of David* painting (pp. 156–57) before. A 1941 illustration that appeared in *Woman's Home Companion*, it effectively contrasts the powerful and powerless. In the foreground, his back to the viewer, is a muscled Roman centurion, his hand on his sword and scabbard. Behind him, a group of humble people are bowed in worship, obviously kneeling before the Christ child, represented by a burst of light.

Then there is his dramatic *Murder in Mississippi*, a 1965 Rockwell departure from sweetness and light. The subject is three slain civil rights workers, and it offers powerful evidence of the artist's virtuosity. One is led to the conclusion that had he chosen, Rockwell could have been an effective spokesman on social issues with his paints and brushes; but it would have been an unnatural voice. Human interest was his forte, not hard news.

My disappointment on my first visit to the museum is that some of my Rockwell favorites are not here. In particular, I'd hoped to see the originals of *Saying Grace* and *Breaking Home Ties*.

Fortyish David Wood is the very articulate, enthusiastic yet businesslike director of the Old Corner House, a job he has had for the past five years. Before assuming his present post, he tells me, he was a teacher in a nearby private school.

Again, I explain my mission and begin my inquisition—first

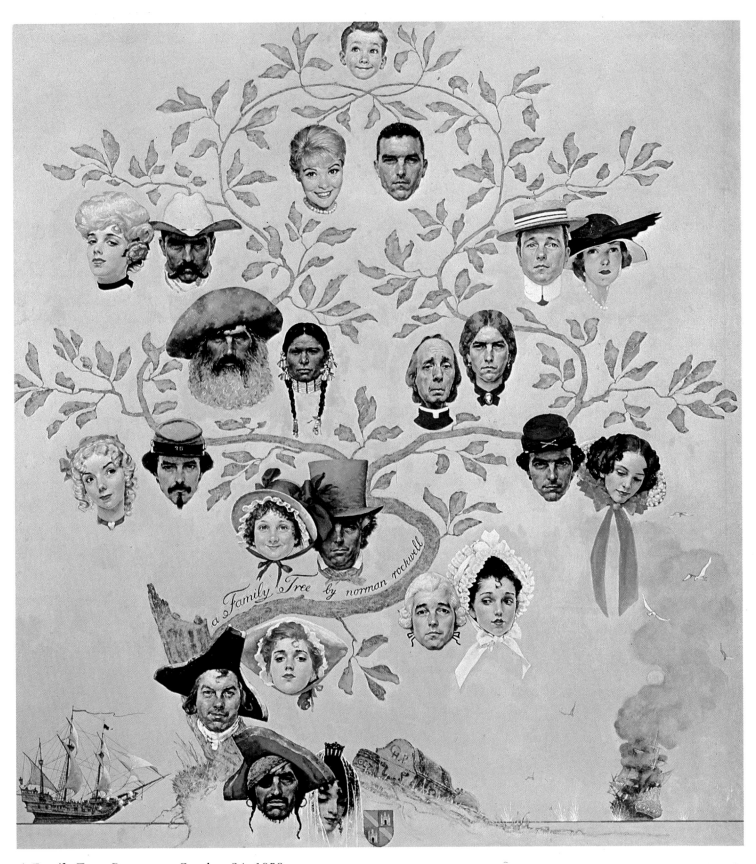

A Family Tree, *Post* cover, October 24, 1959

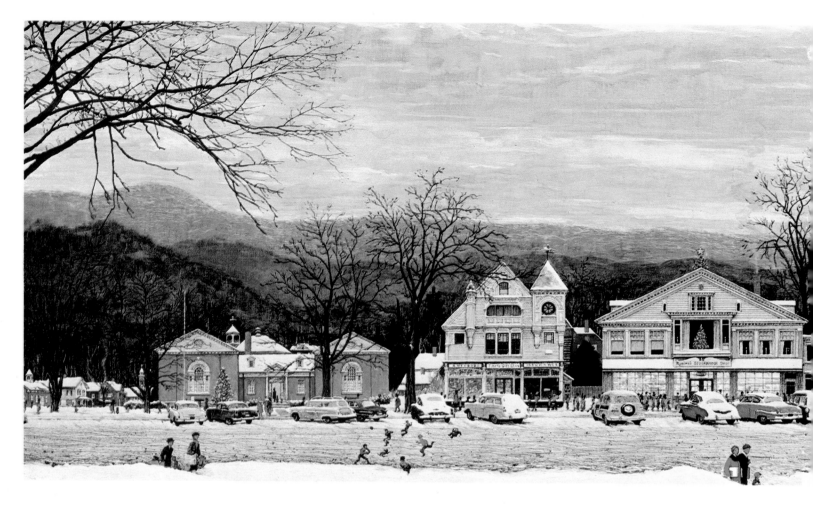

Home for Christmas (Stockbridge Main Street at Christmas), *McCall's* illustration, December, 1967

about the museum. "Does it draw large audiences?"

"Yes, especially in the summer," Wood says. "About 80,000 came through last year. We've had up to a thousand in a single day."

"How are you able to accommodate that many?"

"It's not easy. We need more room and we're limited in this location. The board is considering a move, someplace that would give us more parking and land for Norman's studio."

"Is that building going to become part of the museum?"

"Yes, Norman wanted it that way."

"You lived in quarters behind the Rockwell house, right?"

"Yes, I saw Norman almost every evening after he was through working. It was during those times—relaxing before dinner—that I came to know and appreciate him."

"Was he an easy man to know?"

"More complex than many would suspect," he answered. "But very warm, very open—a man without pretenses or affectation."

"And his life was uncluttered."

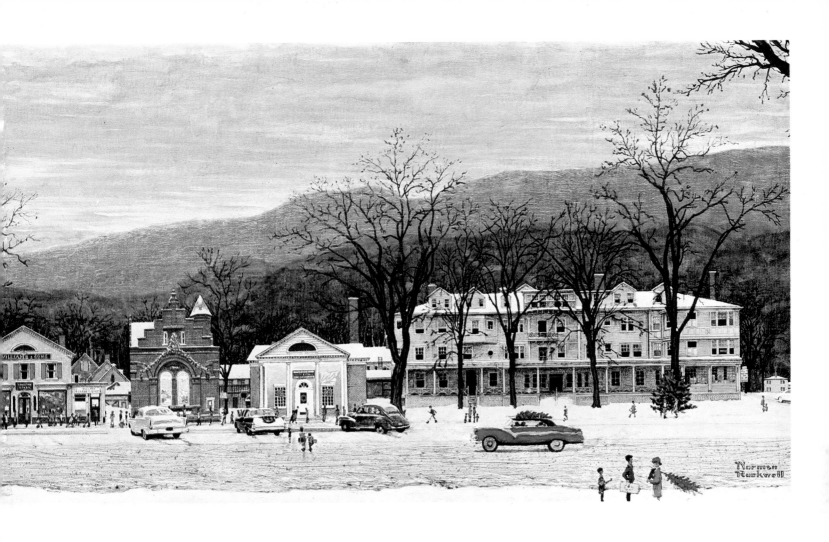

"Painting was his life and he didn't need much more. Money certainly didn't turn his head. Once, I recall a well-to-do businessman badgering Norman to do portraits of himself, his wife and two children. 'No,' Norman said, 'I don't like to do portraits.' But the man insisted and asked him to name a price. Finally Norman said, 'Tell him I'll do them for $25,000 each.' 'Fine,' the man responded and he immediately sent a $25,000 check to cover the first painting. Trapped, Norman did the first portrait, but his heart wasn't in it, and the man was not happy with the result. Norman said, 'Send his money back,' and thus relieved, he wrote *finis* to the $100,000 commission."

"Are you actively trying to acquire Rockwell originals?"

"Yes," Wood says, "but they're very expensive. We have catalogued some 2,800 works and know where most of them are. Our hope is that many people will bequeath their original Rockwells to the museum so future generations will be able to enjoy them. Meanwhile we buy what we can."

"A few years ago, I heard that some Rockwell originals were sell-

17

ing for $40,000–50,000. Recently, I learned that one of his paintings was for sale at $195,000. What's the going price for a Rockwell these days?" I ask.

"I can give you an idea by this story," Wood answers. "One of Norman's most popular *Saturday Evening Post* covers is in private hands. A man of rather modest means owns it. He bought it from Norman in the '40s for $2,000. Recently, a very famous and very wealthy man called and asked me if I could put him in touch with the owner of this particular painting because he wanted to buy it. I said that I could not give him the owner's name or address, but that I would pass his message along. When I called the owner and told him of the interest in his painting, he responded that it was not for sale.

"I carried that message back to the hopeful buyer, who said, 'He doesn't understand. Price is no object. Tell him I'll give him $500,000 for it.' So I called the owner again and relayed this half-million-dollar offer. 'I'm afraid *he* doesn't understand,' the owner replied. 'It is not for sale!'"

"In five years, you've probably made some observations about the Rockwell admirers who have come through the museum. Care to share any of them?" I ask.

"The primary one is that people of all ages appreciate him. His illustrations don't suffer from a generation gap. They seem to appeal to young and old alike."

★

On another day I rise before the chickens and head north out of Stockbridge through Pittsfield and Williamstown, and into Vermont on my way to Arlington, Rockwell's home from 1939 to 1953.

During the 65-mile drive, which is made memorable by a spectacular Berkshire Hills sunrise, I recall David Wood's observation that the artist seems to be popular with people of all ages. If it is so, I tell myself, then he is a genius on one more score, because in this day of scientific audience-measuring, marketing, and polling, demographers know how few people, places, or things have equal appeal to all ages.

Nevertheless, when I look at specific illustrations, I can see broad interest in most of them. Rockwell always seemed to have insight into his subjects' predicaments whether he was looking over his shoulder, agewise, or to the future. His treatment of an aging couple listening to that new rage, radio, in a 1922 painting (p. 22) comes to mind. Although his subjects are of November vintage, Rockwell imbues them with April hearts. He himself was just 28 at the time he drew it. For contrast, consider his painting of exuberant youth in *Scouting Is Outing* (p. 23), painted in 1968 when he was 74.

When I arrive in Arlington, my plan is to find the village coffee

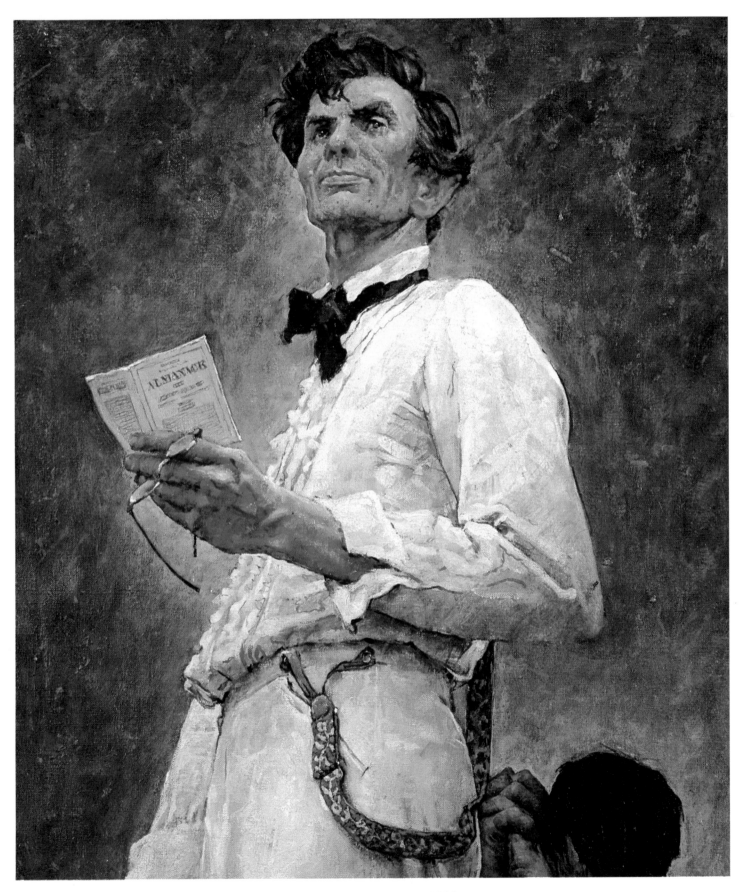

Lincoln for the Defense (Abe Lincoln), *Post* illustration, February 10, 1962

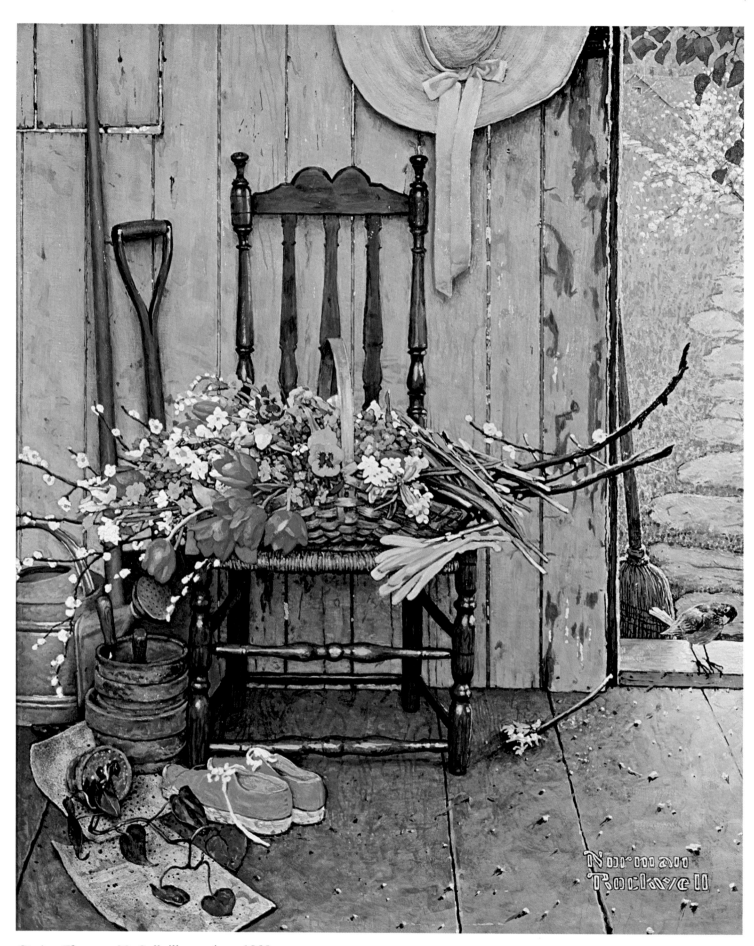

Spring Flowers, *McCalls* illustration, 1969

shop and begin there with breakfast. I grew up in a small town in Ohio (one named by some Vermonters for the place they had left behind: Montpelier) so I know that such a gathering place will help me to get my bearings.

For some reason, I find myself looking for a restaurant that resembles the one in Rockwell's *War News*, forgetting that that illustration had as its setting a Mr. Comar's Quality Restaurant in nearby Manchester. As a result, I quickly find myself through the village without spotting a restaurant. Arlington is one of those communities that can be missed if one blinks.

Turning around, I drive back, trying to decide between an East Arlington and a West Arlington turn, when I come upon The Reddy Hen, an intimate coffee shop that features delicious homemade doughnuts and lively banter between the customers and Phyllis Mull Allen, behind the counter.

After two coffee refills, I introduce myself to Mrs. Allen, and within minutes a half dozen of the people in the place have Rockwell anecdotes to share. Jim Thompson says he posed for him several times and appeared in several paintings. "My father-in-law, George (Pop) Zimmer, modeled for Norman even more often. He's the guy you should talk to, but he's been interviewed so many times I don't know if he'll let you in."

"Where does he live?" I ask.

"Buck Hill Road," he answers. Then several people give me directions—all at once!

Phyllis Allen didn't pose for Rockwell, but her dog did. "I was in high school at the time," she recalls, "and Norman asked to use Champion, our collie, as a model. The morning he was to pick up Champion, the dog decided to go for a swim in our pond. Then he dried himself by rolling in the mud. 'He's a mess,' I told Norman. 'If you'll wait, I'll give him a bath.' 'No, he's fine,' Norman replied, loading Champion into his car. 'The people in the painting are farm folks, so a muddy dog will work out just right.' The painting Champion appeared in was *Breaking Home Ties.*"

Then Dot Immen, who with her husband, Bert, is a realtor, comes into the restaurant with the latest *Saturday Evening Post*. It features several paintings done while Rockwell was in Arlington, and naturally the ones featuring local people hold the most interest for those present.

"Maggie Buck is the woman serving the turkey," says Mrs. Immen, pointing to the mother in *Freedom from Want.*

"That's Jerry Rockwell there," says another.

"That's Don. . . . He's gone now."

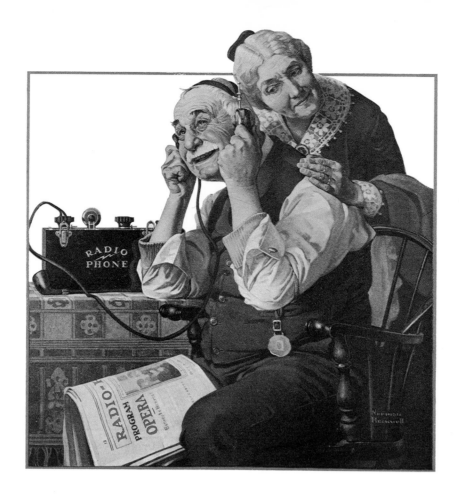

"Is this a local girl?" I ask, pointing to *Girl at the Mirror*.

"Yes, Mary Whalen," says Phyllis Allen, as she pours another cup of coffee. "She's married now, has kids of her own. Lives in Tempe, Arizona."

"That's Mary Rockwell in that one," volunteers someone else. "Oh, what a dear she was. Such a helper in the community. Never too busy to lend a hand. We sure hated to see them move to Stockbridge, and I don't think they'd have left here had it not been for Mary's health."

When I ask Mrs. Immen for directions to find a particular place that was a setting for a Rockwell painting or a person who modeled for one, she proves to be a one-woman Chamber of Commerce.

"The garage Rockwell used for his 1945 painting *War Hero* is this way and Shuffleton's Barbershop is in East Arlington—except it isn't a barbershop any more." When I ask her how to find the old Rockwell house, she directs me west on Route 313.

"We arranged for Norman and Mary to buy it," Mrs. Immen recalls, putting her realtor hat on. "When it came on the market we hesitated suggesting it, however. We thought Norman might think it

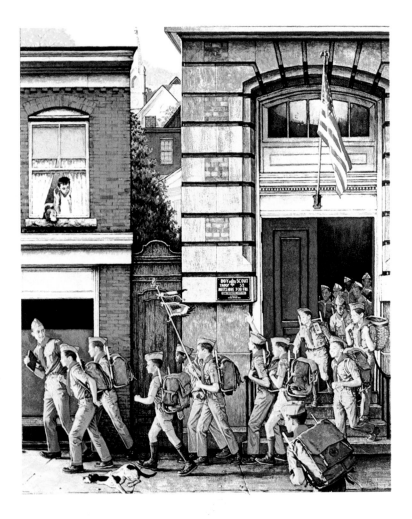

Scouting Is Outing
Boy Scout calendar, 1968

too close to another house. Jim Edgerton's place was just across the driveway. But that didn't matter to Norman. He and Jim became close friends."

Then she interjects a personal memory. "At the foot of the hill leading up to the old Rockwell place is the Grange hall. Norman and Mary loved to square dance, and about every Saturday night we'd gather there. Such good times we had. . . . Norman was usually one of the first ones there because he had a special job to do: he always swept the floor."

Heading out Route 313, I find the Shell station for which I'm looking just past the volunteer fire station. I pull my car up to the pumps and wait, but no one emerges from the station, so I get out, walk to the front door, stick my head inside and give a shout. No one answers.

As I turn around, a man ambles up the walk from a neighboring house. When he reaches me, I ask him to "fill 'er up."

"Are you Carl Hess?" I ask. When he responds yes, I introduce

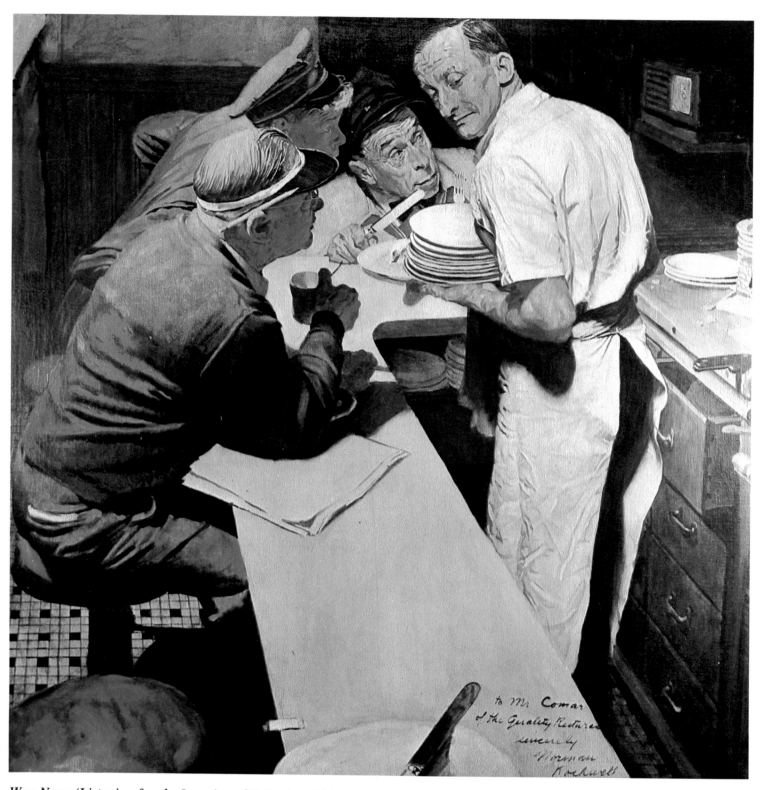

War News (Listening for the Invasion of D-Day), c. 1945

24

myself and tell him about the book I'm preparing. Carl Hess is the man who modeled for Rockwell's *Freedom of Speech* painting.

At first, Hess seems rather reticent to discuss his role. "I suppose you've been interviewed a lot," I suggest.

"Yes," he replies. "Had a Boston writer in here a while back. He made us sound like backwoods hicks."

I tell him that I grew up in a small town and have lived in places of all sizes, but that I prefer towns like Arlington and the people that go with them. "I guess Norman Rockwell did, too."

"Yes, there wasn't anything highfalutin' about him," Hess agrees. As he talks, I notice he stops regularly to take a snort on a vaporizer that he holds in his hand.

"Got a cold?" I inquire.

"Emphysema. This cold weather is tough on bad lungs. Only the third time I've been out all winter."

He finishes pumping gas, and I fear our conversation is about to end, so I ask what I am sure will be my last question. "Tell me how Rockwell came to choose you for *Freedom of Speech.*"

"He said I had the right look—noble-like," Hess says with a half-smile. "Rockwell got his inspiration from Jim Yedson. He lives over there." He points to a nearby house. "Jim stood up at a town meeting which Norman attended. That was where he got the idea. As you can see, I've gained a little weight since 1943—about 100 pounds. And a few years," he adds. (I do some quick math. Carl must have been 35–40 when he posed—37 years ago.)

By now Carl Hess has warmed to his subject. After I pay him for the gas, he leans up against the car, forgetting the chill and his emphysema. He has pocketed his vaporizer and is gesturing with both hands. The talk about Rockwell seems to have taken 20 years off him.

"I'll never forget the time Norman drove in to have me put snowtires on his car. It was just after the War. He was driving a Ford station wagon with wooden panels in the doors. Well, I was busy at the pumps when he pulled in, so rather than wait for me to direct him into the station, he raised the overhead door and drove in by himself. Only problem was, he missed the lifts and ran his right front wheel into the pit. When I looked up, he was coming out all flustered. The car was resting wapper-jawed, front end down, rear pointing toward the moon. 'I'll get it in the morning,' he said disgustedly. Then he tramped off through the snow toward home."

Just a stone's throw from Carl Hess's station is the old Rockwell home, the second one. The first place Norman and Mary lived was where Rockwell's studio burned.

With that fire—caused, Rockwell believed, by ashes spilled from

his pipe—the artist lost many favorite illustrations, costumes and props, a file of clippings and sketches of projects in the works. The extent of the loss will never be known because Rockwell had no inventory of the paintings in his studio.

Fortunately, he had not long before finished the four *Freedoms* and they were at the *Saturday Evening Post* in Philadelphia.

The fire was discovered by Tom Rockwell about 1:15 on the morning of May 15, 1943. Tom and his brothers Jerry and Peter were all down with the measles at the time. The fire department was called, but by the time they arrived, it was too late to save the studio.

After the flames had been extinguished, the Rockwells served coffee and doughnuts to firemen and visiting neighbors, some of whom sat on the lawn talking until dawn. Rockwell's only lament at the time was the loss of his favorite pipes. (The next day friends thoughtfully brought him some replacements.)

Characteristically, Rockwell took the loss in stride. Making lemonade out of the "lemon" he'd been given, he recorded the loss in a series of lightly handled sketches, which appeared in the *Post*.

And there was one other benefit: prior to the fire, townspeople had always referred to the celebrated illustrator as Mr. Rockwell, despite his stated preference that they call him Norman. "After the fire," Rockwell told someone much later, "I was finally accepted as one of them, and from then on I was called Norman by everyone."

The setting for the house the Rockwells occupied from 1943 to 1953 is a Currier and Ives engraving come to life. Mountains rise on either side of this fertile green valley parted by an idyllic brook. Turning from the highway, I enter Covered Bridge Road and immediately drive through a small covered bridge that spans the Batten Kill, a fast-moving stream famous for the trout it yields. On my left is the old, unoccupied one-room schoolhouse Rockwell used briefly as a studio. On my right is a white clapboard church and the Grange hall.

At the head of the lane stand two early 19th-century houses, which I know from descriptions are the Edgertons' on the left and the old Rockwell place on the right. Huge maples frame them. The Edgertons' side is backed by barns and outbuildings, indicating it's a working farm. The Rockwell side has a garage, two studios and an overgrown tennis court.

Knocking on the door of the former Rockwell residence, I raise Mrs. Walter Finney, who now calls the place "Grandmother's House." She explains that since her husband's death she has opened the house to guests, accommodating as many as eight at a time. In the winter, she draws skiers; in the summer, tourists, who come for music festivals, theater, fishing, and so on. "It's a great place just to loaf," she says.

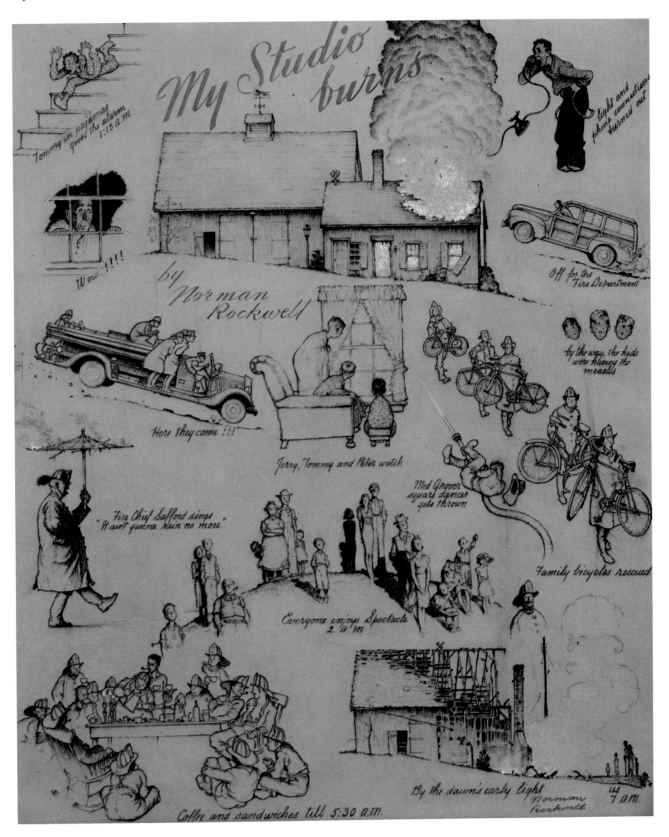

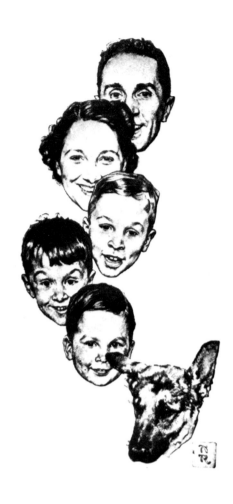

*Rockwell Family: Portraits of
Norman, Mary, Jerry, Tommy,
Peter, and Raleigh Rockwell,* c. 1940

"Do people still call this the Rockwell place?"

"I don't," she replies. "I've been living here a lot longer than they did." Yet she is well aware of the imprint left by the former owners. Looking behind, I ask about the two studios.

"Norman used the bigger one; his son Jerry, the smaller one. A young couple is renting the one studio now. The other is used for storage."

"Are the Edgertons around?" I ask.

"No, Jim is in the hospital," she tells me.

"Where are the birches that Rockwell wouldn't allow lumbermen to cut?"

"Across the road on the hill," she says, pointing in the direction of acreage that Rockwell kept even after he sold this house and moved to Stockbridge. The story reveals another appealing side of Rockwell.

When loggers wanted to take timber from the forty-five acres that sit opposite the front of the two houses, Rockwell had given them permission, "providing you don't take any birches that Jim Edgerton can see out his front door."

Before I leave town, I visit two more people who spent more than a little time with Rockwell. One is Jim Martin, the other Pop Zimmer.

Martin is most famous for being a model for *Freedom from Fear*, the painting that shows two parents looking over their sleeping children.

"I'm in all four *Freedoms*," volunteers Martin, a retired carpenter.

"Oh," I respond, "where are you in *Freedom of Speech?*" He leads me to the staircase where several prints of Rockwell paintings are hanging.

"Right there," he says, pointing. And then he singles himself out in the others.

"Any idea why he chose you?"

"No, but I know when he first did." Then, pointing out his kitchen window at a nearby house, Martin says that Miss Ethel Drummond, a piano teacher, used to live there, and she held a recital in her home one Sunday.

"Tommy Rockwell and my daughter Janet were both students of hers. When my wife and I arrived for the recital that day, most of the chairs were taken, so I stood in the doorway. Rockwell was sitting on the floor across the room.

" 'Hey, Jim,' he called, 'come over here and sit with me.' When I did, he said, 'I was just looking at you standing up there. I've got a painting to do, and I need a model. Would you be interested?' . . . That's how it began."

My last stop in Arlington is at Pop Zimmerman's, a man I'm told is in his 80s and lives alone. When I knock on his door, I'm greeted by a round-faced pixie with happy eyes and a smile as warm as July. He reminds me of my Bavarian-born Grandpa Bauer in appearance and of a Rockwell statement about the kind of people he found in Arlington: "Right here are the exact models I need for my purpose. They are sincere, honest, homespun, the types I love to paint."

He was also quoted as saying:

> If you are interested in the characters you draw and understand them and love them, why, the people who see your picture are bound to feel the same way.
>
> It would be difficult to paint individuals who have lost their faith. I could sketch the outline of their faces, but the inner glow that gives them character would be missing. . . .

Pop Zimmer is both a character and full of character. He posed for such Rockwell successes as *Armchair General* (p. 130) and *The Swimming Hole* (p. 119). What did he think of the artist?

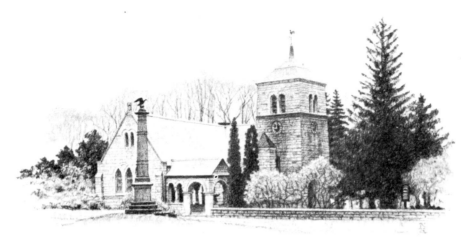

St. Paul's Episcopal Church, undated

"Wonderful fellow," he enthuses as he shuffles to a magazine rack and carefully pulls out some prized keepsakes, dog-eared *Saturday Evening Posts* from the '40s. "Here, I modeled for this one," he says, "and this one."

"What are your recollections about Rockwell?" I ask.

"I remember the night his studio burned. I was coming home from bowling, saw the light in the sky. We drove right out, offered to bring the kids home for the night, but Norman and Mary said they'd be all right." Then he looks at the ceiling trying to stretch his memory. What he remembers is a footnote to that night that capsules what small-town living is all about. "I'm not sure," Pop says, "but I believe that Peter, Tommy and Jerry all had the measles."

Before I pack my bags and leave Rockwell land, I return to Stockbridge to spend an afternoon in the village library, sorting through a large file of clippings dutifully kept since Rockwell came to town.

Librarian Polly Pierce, who helpfully answers the sundry questions I throw her way, tells me that she served as model for John Sergeant's wife in the unfinished painting I'd seen in Rockwell's studio. ("I told him that Abigail was younger than I am," she recalls, laughing, "but he said it didn't matter.")

Among the random and unrelated notes I make from the clipping file are these . . .

Rockwell's house on South Street was built by the Rev. Samuel P. Parker, who was the first minister of St. Paul's Episcopal, the church in which Rockwell's funeral was held.

Drawing a distinction between painting and illustrating, Rockwell once modestly concluded he was only an illustrator, but added, "Michelangelo was an illustrator when he did the Sistine Chapel, wasn't he?"

Scott Ingram, who was 6½ when he modeled for the painting that shows a boy discovering a Santa Claus suit in a chest of drawers, was at last report married and working as a marketing representative for a mail order company in California.

When Rockwell received an honorary doctorate from Middlebury College in 1952, the *Saturday Evening Post* reported that "he just told anecdotes about his work and the intelligentsia loved it."

When interviewed at age 80, Rockwell told the writer that he didn't want to retire to Florida. "I want to be working on a picture and just fall over dead."

In a 1970 *New York Times* book review, it was said of Rockwell that he was "held hostage by a public interest in the anecdotal rather than the aesthetic statement, and only in his latest work has he freed himself from the burdensome view that all's right with the world."

A follow-up on the story about President Johnson calling Peter Hurd's portrait of him "the ugliest thing I ever saw" and then pointing to Rockwell's picture, of which Johnson approved: "I took out the wattles under his chin and shortened his ears a little," Rockwell confessed mischievously.

From his obituaries: "His sentimental and whimsical scenes of small-town life came to represent America at a simpler time. . . ."

And: "His popular trademark was apple-pie America. . . ."

And: "Fifty years earlier, he would have been a neat and nimble draftsman; no worse, no better. . . . But in the heyday of the weekly magazine, Norman Rockwell spoke loud and clear for the majority, who knew it at once and said 'Thank you.'"

Now I am ready to close up shop on my Rockwell research. Oh, I'll read everything else I can find that has been written about him before I go to the typewriter, and I'll visit his birthplace in New York (the corner of 103rd Street and Amsterdam Avenue has changed a little since the turn of the century), his childhood haunt, Mamaroneck, and his old home in New Rochelle. And I'll talk to lots more people who knew him socially and professionally, and I'll visit the Boy Scout Museum in New Brunswick, New Jersey, and view his work in other exhibits, but as far as the years 1939 to the present, his Arlington and Stockbridge years, I'm satisfied that I've found the essence of the man for whom I came searching.

As I make one last pass through town, there is only one more place I care to visit. Walking past the old church where his funeral

was held (Rockwell once did a drawing for their church bulletin), I make my way to the cemetery where his body was laid to rest. Here are graves that date back a couple of hundred years.

Snow covers the ground, but the sun on my face suggests that winter is about to lose its hold. Before I reach the stone marked Rockwell and the spot where Mary and Norman are buried, my attention is stolen away by tracks made through the snow by two youngsters pulling two sleds. They are accompanied by a dog. The size of the footprints tells me the kids are about 8 to 10 years old. Immediately, a picture comes to my mind and my imagination takes over. They are boys, maybe brothers, on their way to a neighboring hill where they can throw their sleds down and bellywhop with abandon. A place where the dog—a black-and-white mutt, I'll bet—will nip at their heels and bark when they run.

Suddenly, the somberness that I bring to this somber place takes wing. And I smile to myself, realizing what has happened. I've been "Rockwelled." I came here to pay my respects to an artist I take seriously, but the kid from Amsterdam Avenue who never grew up won't let me get maudlin. Though he's painted his last sledding boy and barking dog, his impact on all of us is so great, his insights so poignant, that we can't forget the faith-perpetuating pictures he drew. We see parallels of them in our everyday experiences, and when we take time to appreciate them, our lives are enriched and blessed. As a result we forget our cares, for the moment at least, and we go on our way less burdened than before. That's the legacy Norman Rockwell has left us, and he deserves our thanks.

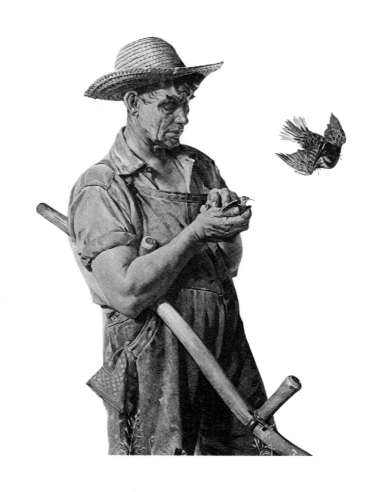

1. FAITH IN OUR FRIENDS
AND NEIGHBORS

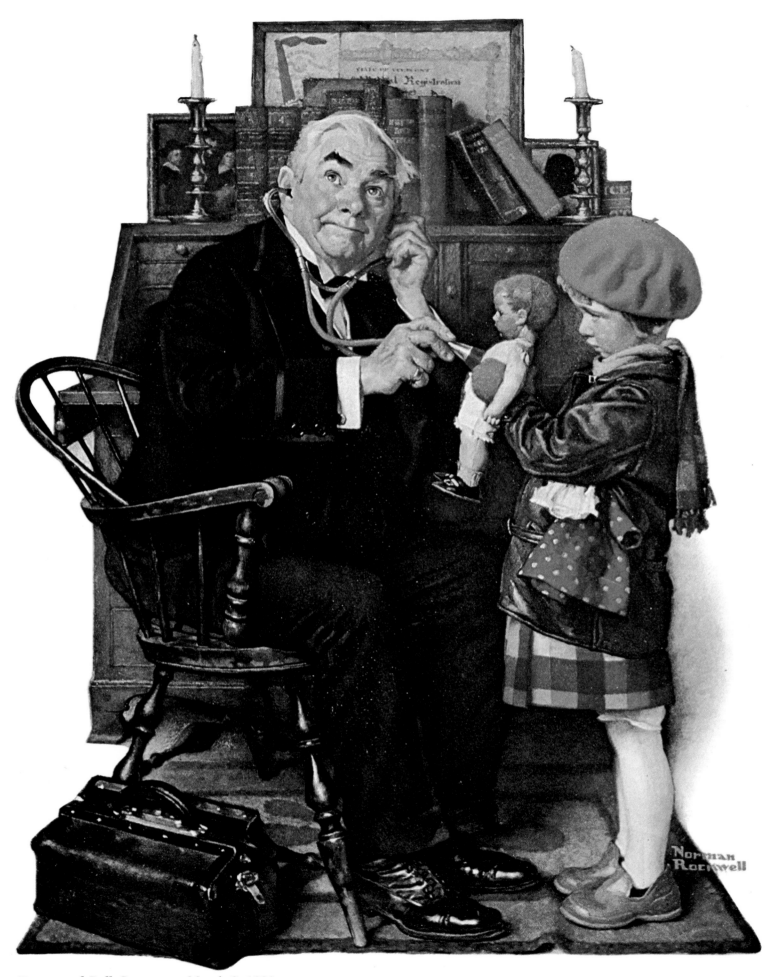

Doctor and Doll, *Post* cover, March 9, 1929

Ten years ago, I'd guess—maybe more—I was sitting in a barbershop looking at a magazine that featured several favorite Norman Rockwell illustrations. As I studied them, I realized that they had one clear common denominator: faith. The kids in Rockwell's paintings obviously have faith in their parents and vice versa. His husbands and wives have a faith in their eyes that tell you their marriages will last. Neighbors have faith in neighbors. Americans have faith in America.

Oh, Rockwell may throw in a little dab of satire or irony now and then, creating a momentary illusion of doubt, but his viewers aren't fooled by such smoke screens, and they quickly flick aside the doubts as one would brush away sparks from a bonfire.

From that day in the barbershop on, I have been intrigued with the idea of bringing together a selection of Rockwell's paintings, which en masse would make an unqualified statement of faith, a book to which one could turn occasionally for a smile, a lift, sustenance, and succor. Why Rockwell? Because I think he is good for our individual and corporate psyches. Every generation needs a Rockwell to remind them that despite their worries and fears, their disappointments and failures, life will go on—probably about as it has before. And that's not all bad, Rockwell whispers again and again, as he adds another freckle to a farm boy's face or brushes more blue into the sky. There is always hope that human nature will change a smidgen for the better, he seems to be saying. To such faith and hope is Rockwell blissfully wed.

St. Paul told us in the book of Hebrews (11:1) that "faith is the substance of things hoped for, the evidence of things not seen." If any quotation, motto or slogan more distills the philosophy of Norman Rockwell than this Bible passage, I cannot conceive of it.

Throughout his long career, he painted idealized subjects in idealized settings pointing toward idealized conclusions, showing a world hoped for but seldom seen. When asked once why he didn't paint life more realistically, Rockwell replied, "Maybe as I grew up and found the world wasn't the perfectly pleasant place I had thought it to be, I unconsciously decided that if it weren't an ideal world, it should be, so I painted only the ideal aspects of it—only foxy grand-

35

pas who played baseball with the kids and boys fishing from logs and got-up circuses in the backyard."

For art critics who require that artists turn their subjects inside out to probe for deeply hidden psychological meanings, Rockwell gets low marks.

For the social commentators who insist that artists make strong statements about the ravages of unjust wars, child abuse, ecological deterioration, poverty, hunger, crime, and violated civil rights, Rockwell is tea without lemon.

But for millions upon millions of Americans who judge art on the basis of how it makes them feel, those who want to be entertained rather than preached at, amused rather than agitated, and warmed rather than weighed down, Rockwell is the best of them all, bar none, hands down, no contest.

He won his high standing by faithfully drawing American scenes and subjects in their best possible light, a trait that put his canoe clearly in the mainstream. Optimism is deeply ingrained in our nation's character, and always has been. From indomitable pilgrims to moon-walking astronauts, we have always been a positive people.

In Norman Rockwell's world, there is reason to have faith, because it is a world filled with caring people who demonstrate their caring with good deeds. In his world, we find doctors who didn't learn their bedside manners from psychology textbooks, but from the laboratory of living. Rockwell's physicians make housecalls because humanitarian service is their calling. Never mind that a doctor nowadays has more sophisticated equipment at his office or that there he can treat more patients more efficiently: we all know that healing comes as much from our belief in the dispenser of the medicine as from the medicine itself. Didn't mother's camphorated salves rubbed gently on our chests cure us of everything from pneumonia to chicken pox?

In Rockwell's illustrations, we see doctors in whom we can believe totally. Whether the patient is a little girl's doll (p. 34) or a real-for-sure baby (pp. 38–39), the result is predictable: healing. We know this intuitively; besides, Rockwell doesn't deal in terminal illnesses or malpractice suits.

In Rockwell's domain people have faith in all their friends and neighbors, however, not just in professionals with diplomas on their walls. Who is not touched by the compassion of the movers who take time to coax Fido out of the alley (p. 40)? It is such a small slice of life, but in Rockwell's gentle hands this insignificant episode becomes a community-wide concern of life-interrupting importance. Note the people drawn into the scene—the delayed bicyclist, the postman, the

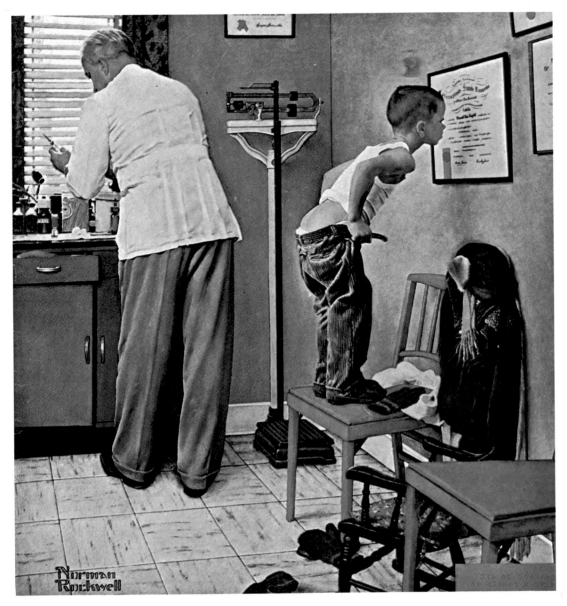

Before the Shot, *Post* cover, March 15, 1958

young violinist (left foreground) who is no doubt late for his lesson with the teacher (top center), the window washer, the artist and his model, and the family on the porch: baby in drooping diaper, Pop in undershirt, and Mom in hysterics. In a Rockwell painting everyone is involved.

Public officials care, too, like the policeman dealing with the runaway boy (p. 41). Judging from the understanding looks on the faces of both the officer and the restaurant counterman, one gets the feeling that they, too, have entertained thoughts of running away, certainly when they were children, maybe once in a while as adults. After all, Rockwell seems to be saying, don't we all get tired of the routine

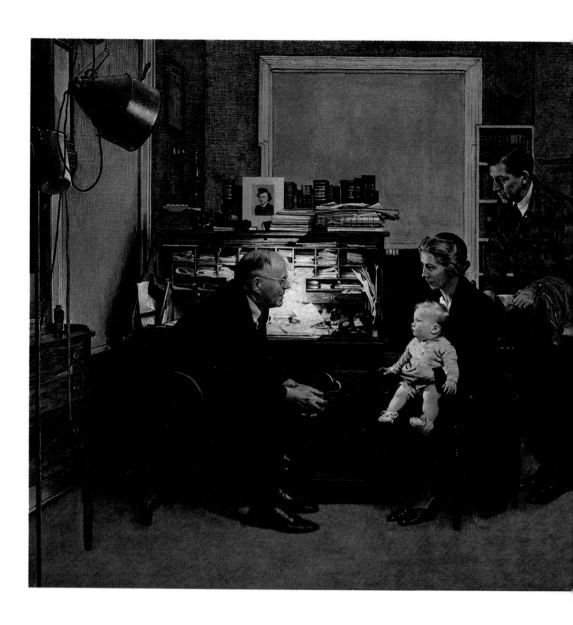

occasionally and long for greener pastures out there where real life
and romance and adventure are?

We know that in the end the boy will be given a glass of milk and
a piece of chocolate cake, compliments of the house, and a free ride
"almost" home by the officer. Unless I'm a poor judge of character, I
believe the officer will suggest that the boy slip in the back door and
unpack his bandanna before Mother and Dad miss him, and that he
postpone his trip around the world until the week after next.

Rockwell appreciated his neighbors and wanted to be accepted by
them as "just another guy on the block." The fact that he painted
himself into so many work-a-day illustrations suggests how unpreten-
tious the nation's best-known artist was. Always good with small talk—
be it with Presidents or kids—Rockwell reported the following conver-
sation with the Manchester, Vermont, rationing board (pp. 42–43):

"May I paint the board at work?"

"If you make us look good," the chairman answered.

"If I make you look good, will you give me a B gas card?" Rockwell teased.

"No, but if you don't, we'll take away your A card!"

Again, the faces of the board are those of caring people, dedicated community leaders who can be trusted. The man facing the group may not get a B card either, but one can be certain his case will handled fairly, just as one can be sure the people in the country newspaper office (pp. 44–45) can be counted upon to write the news impartially.

As a former country-weekly editor, I recognize the white-haired editor at the typewriter. I've seen him in dozens of newspaper offices. He prints all the news with unflappable even-handedness. And he gets the facts right, deadline or not.

Traffic Conditions, *Post* cover, July 9, 1949

Everything about the painting is on target—the retired subscriber (I'm guessing) in the wicker chair who comes by to get his paper "hot off the press," the dingy walls that haven't been painted since Hoover was President, and the farm couple placing a classified ad to sell "one three-year-old Holstein heifer, fresh." Looking at the drawing, I can practically smell the hot linotype and oily ink from the backshop. The only thing I question is the artist coming through the door with a painting. Rockwell knew, of course, that small-town newspapers can't generally afford original illustrations, but then I suppose artists should be allowed to take poetic license, too.

One can also have faith in the school teachers Rockwell painted (pp. 46–47 and 48). Of course, they teach in one-room school houses with inkwells and potbellied stoves. And they are loved and respected by every last one of their well-mannered students. And the students'

40

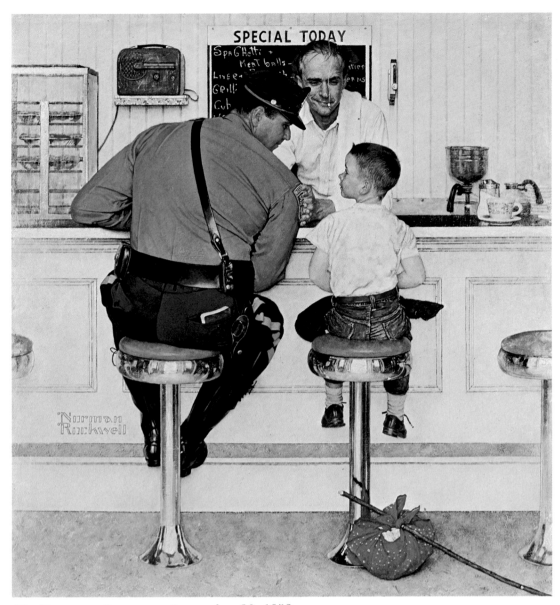

The Runaway, *Post* cover, September 20, 1958

parents. There isn't much conversation about impending teacher strikes or whether Johnny's SAT scores will be high enough to get him into Yale. In such humble citadels of learning, however, people *do* talk a lot about the three R's.

In Rockwell's world, we know that neighbors like Rosie the Riveter (p. 49) will take up the slack in the male-depleted work force and will help us win the War; that sandlot ballplayers about to be deposed by excavators will win a reprieve or work out a compromise (p. 50); that although the postman may occasionally take too much interest in our correspondence (p. 51), we will get our mail on time; and that even though our strongly held opinions sometimes get us into hot water with our friends and neighbors (p. 52), we in the end will be exonerated on the grounds that "it is the principle of the thing."

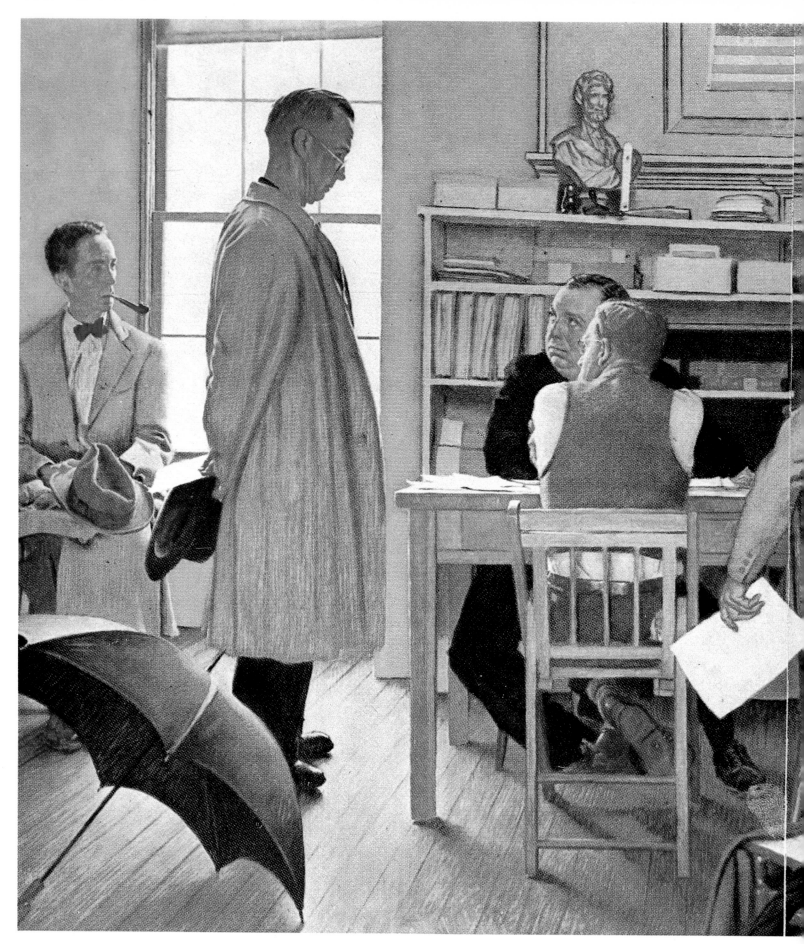

Norman Rockwell Visits a Rationing Board, *Post* illustration, July 15, 1944

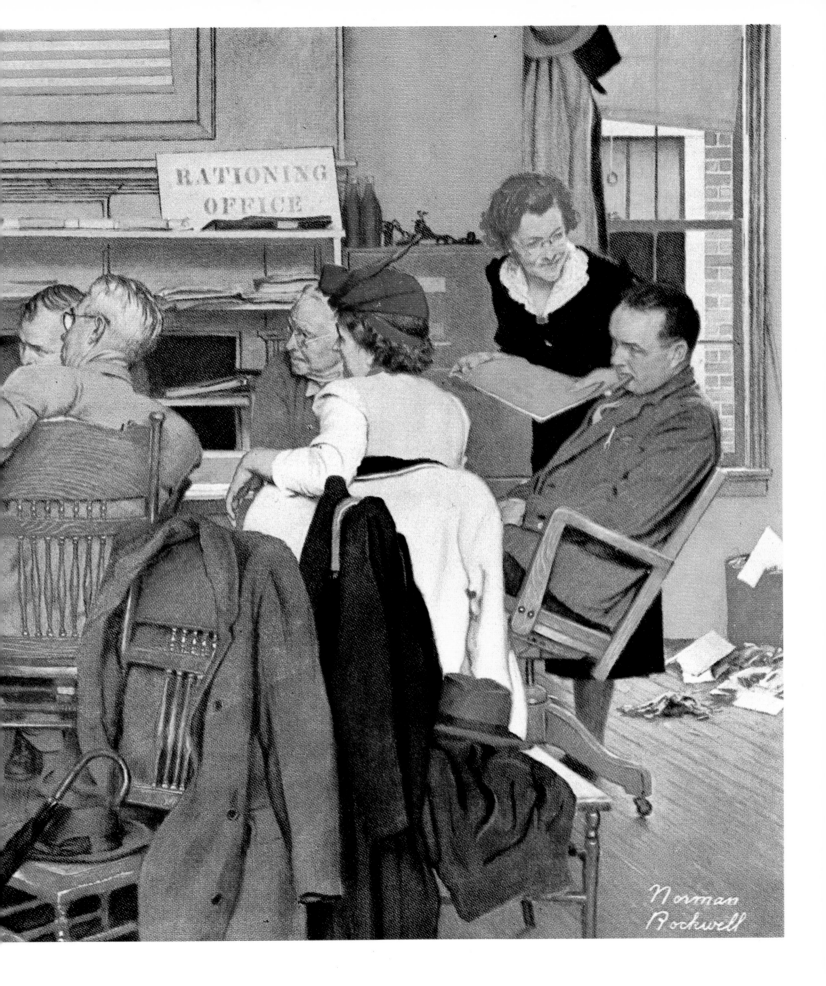

43

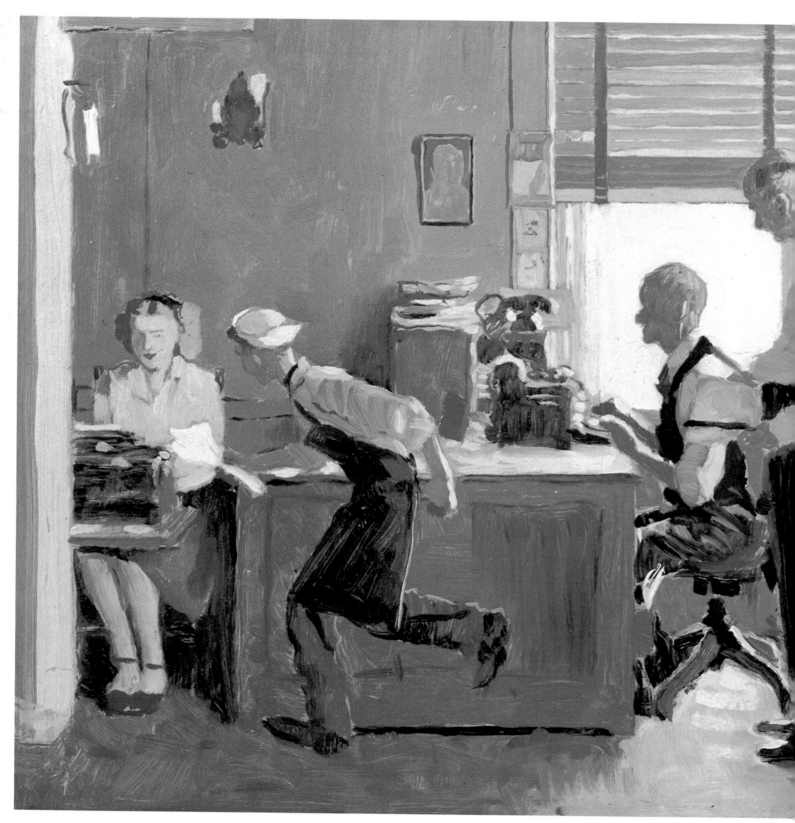

Norman Rockwell Visits a Country Editor, Oil sketch for *Post* illustration (final painting, May 25, 1946)

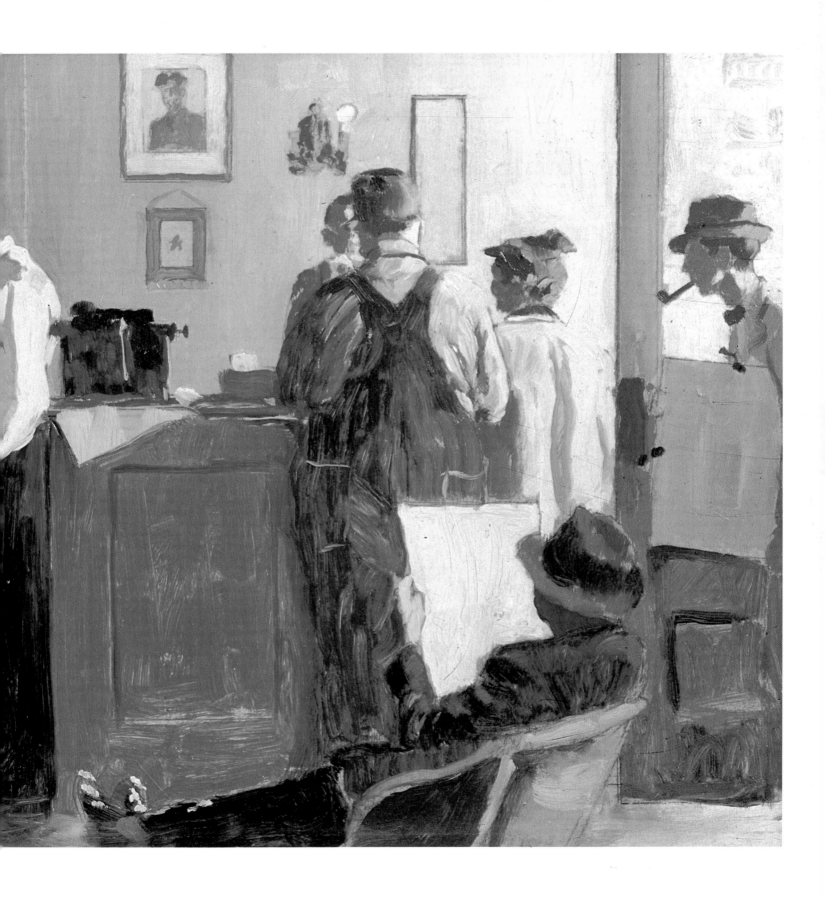

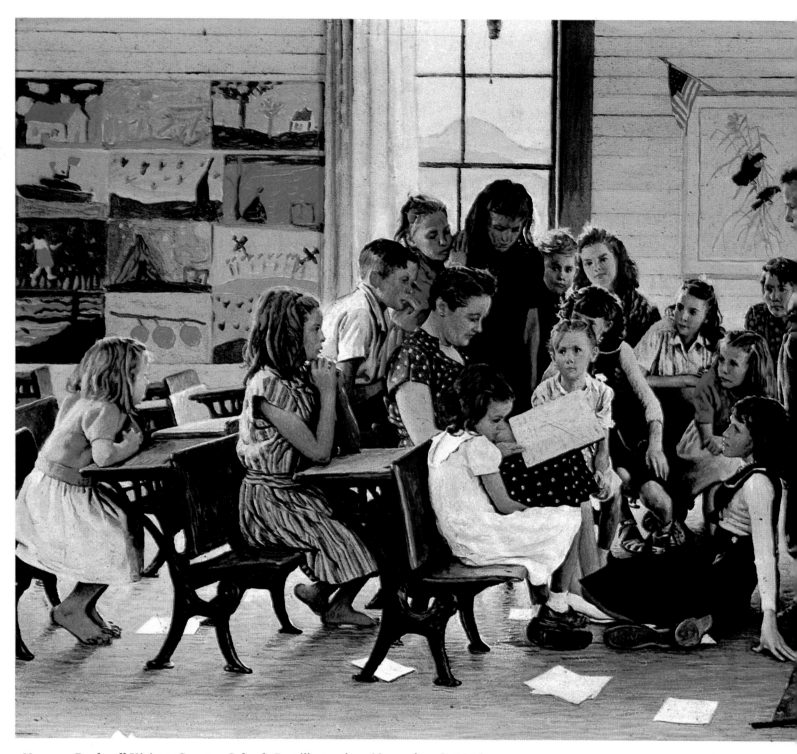

Norman Rockwell Visits a Country School, *Post* illustration, November 2, 1946

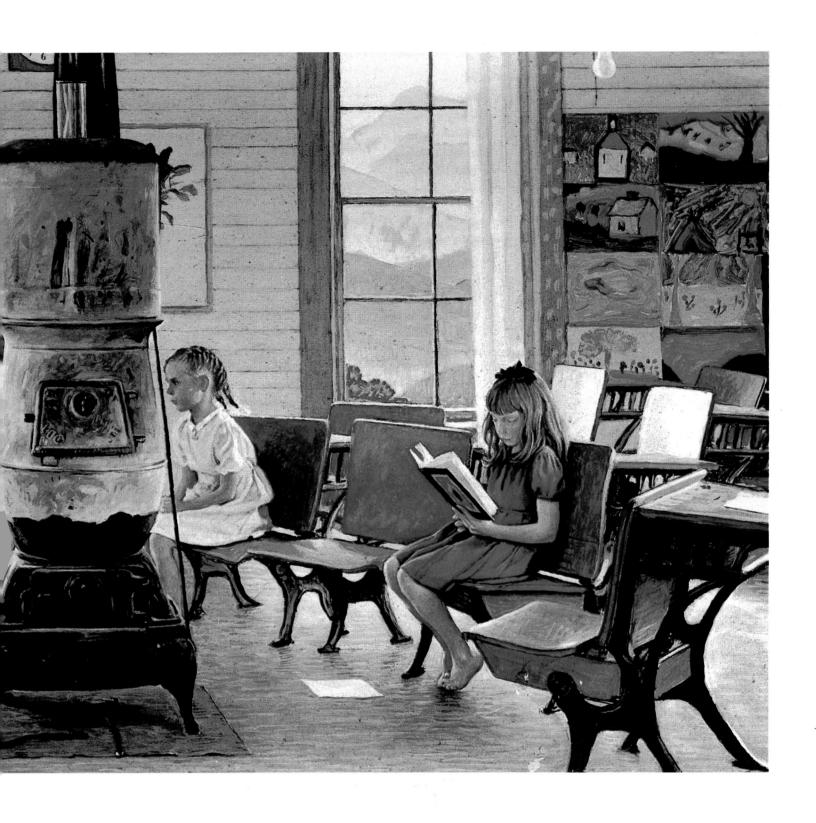

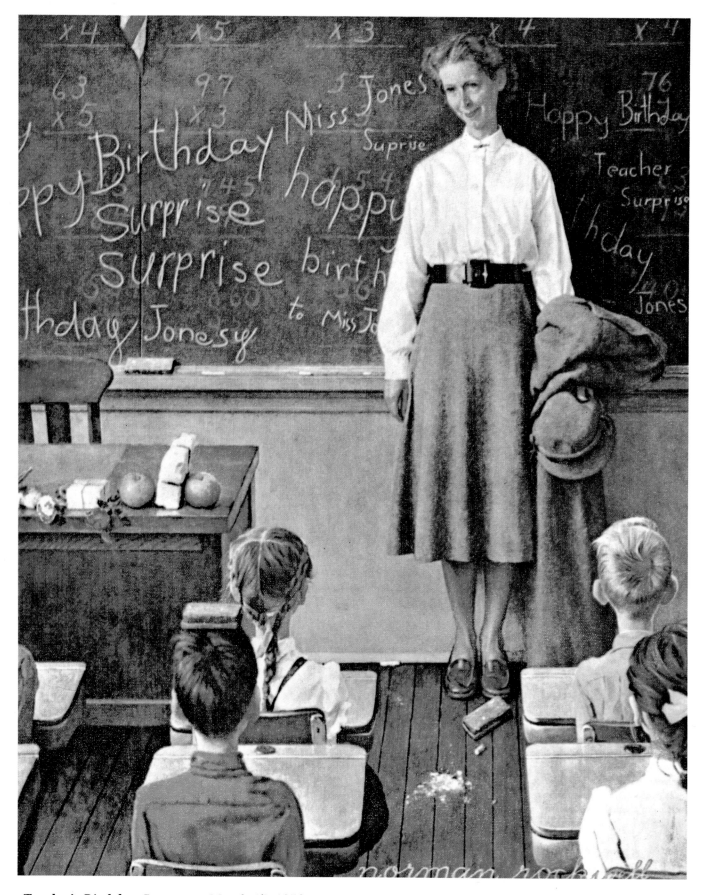

Teacher's Birthday, *Post* cover, March 17, 1956

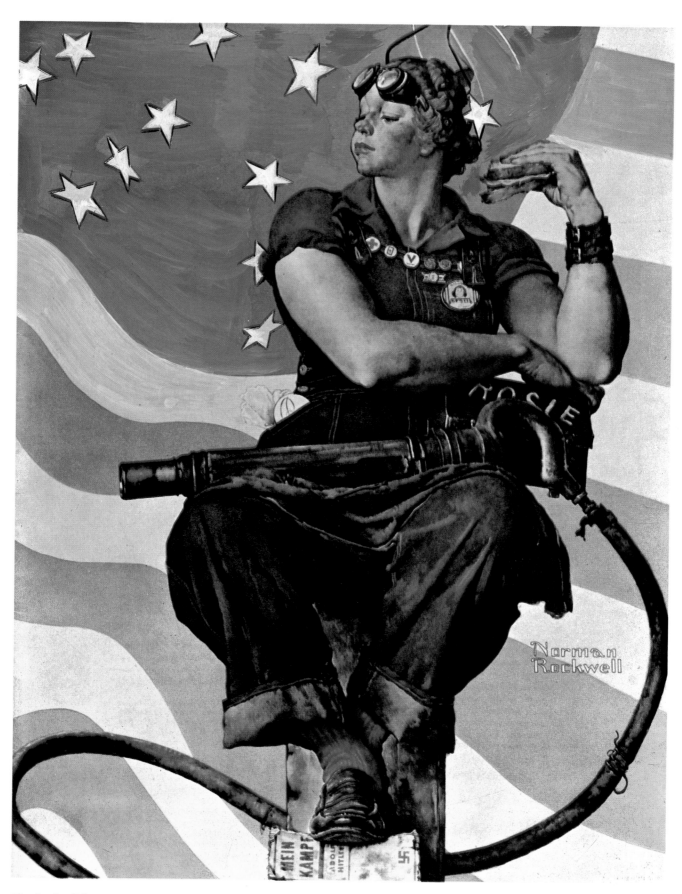

Rosie the Riveter, *Post* cover, May 29, 1943

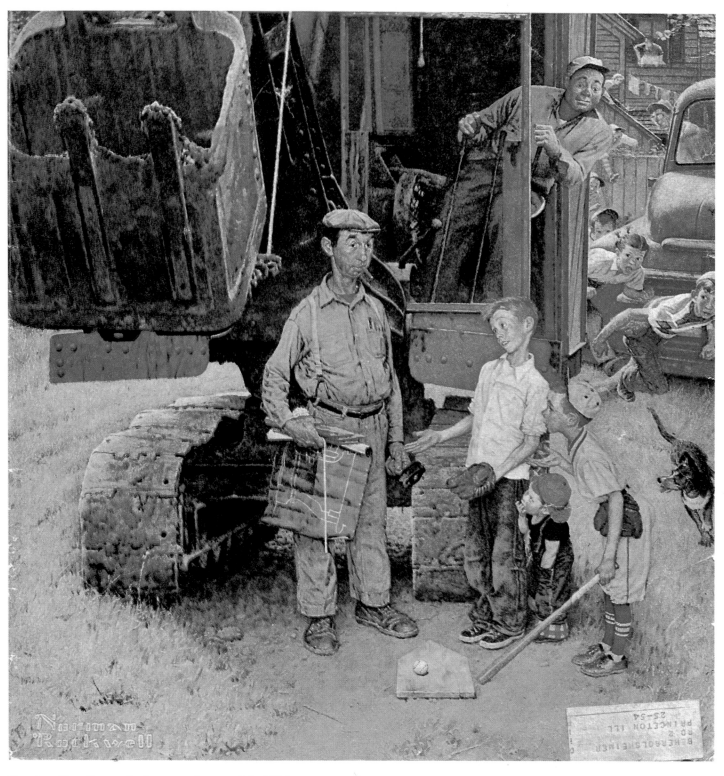

Construction Crew, *Post* cover, August 21, 1954

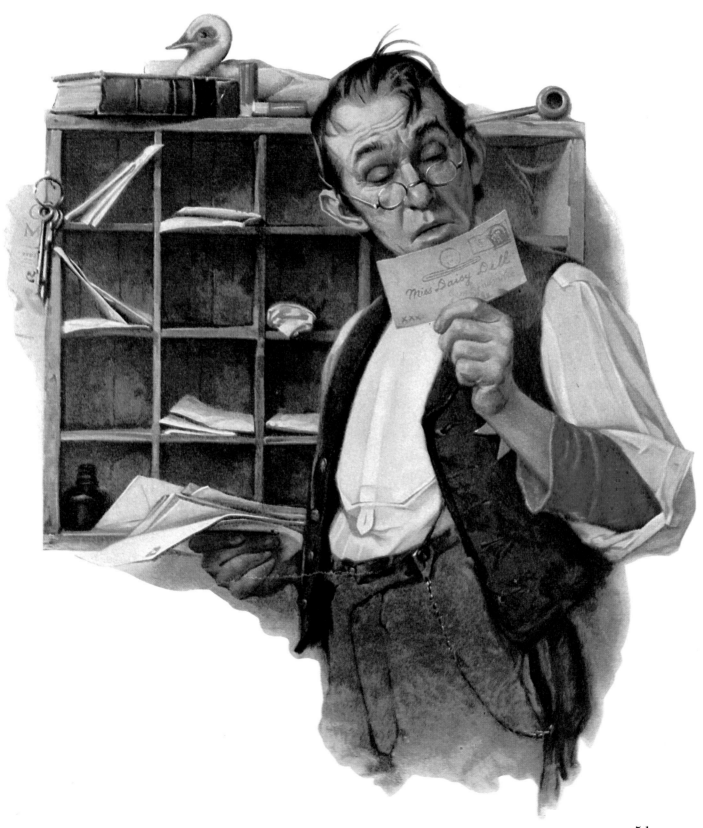

The Winner, *Post* cover, May 23, 1953

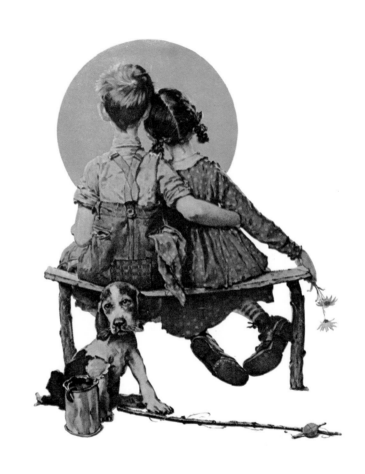

2. FAITH IN OUR LOVED ONES

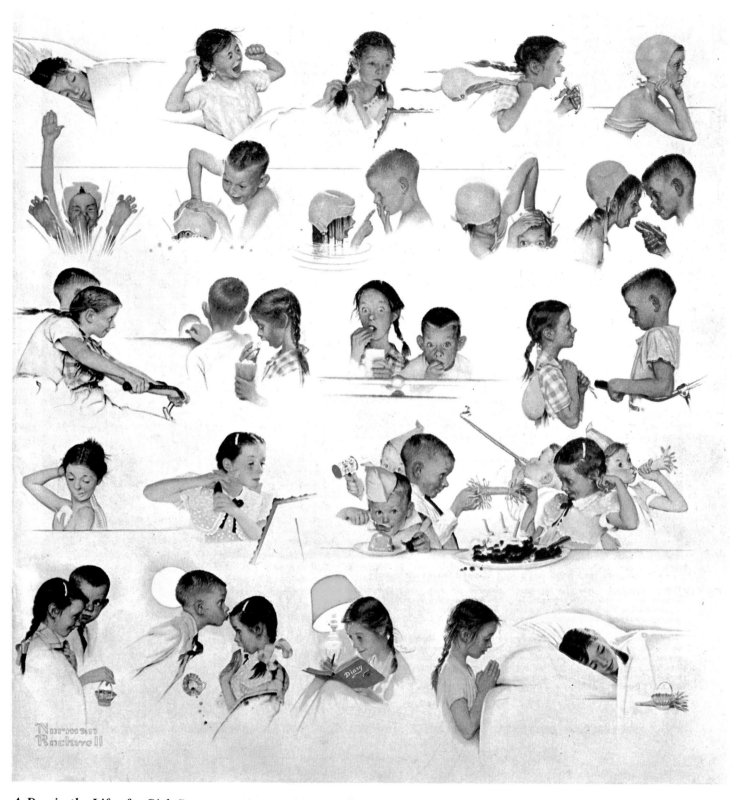

A Day in the Life of a Girl, *Post* cover, August 30, 1952

That Norman Rockwell was a strong family man is undeniable. The loving insight he brought to family life with his brushes and paints could only have been rendered by someone who got his information and inspiration from inside a closeknit family circle. Outsiders don't understand about tooth fairies and college tuition payments on the installment plan, about midnight croup and all-night slumber parties, the importance of visits to and from the grandparents, new prom formals, addressing wedding invitations, birthday puppies and Christmas bicycles, spring tonics and winter tonsillitis; but Rockwell understood and he proved it in his work by time and time again touching the funny bone of truth—the half laugh, half sigh that emerges from our inner beings when someone points out a reality that our souls know, but have kept a secret.

In his warmly revealing and self-effacing autobiography (written with his son Tom), Rockwell says that he didn't really feel close to his father, whose preoccupation seemed to be making ends meet (he was employed by a New York City textile firm), or to his frail mother, who, although she lived to be 85, was forever abed with illnesses that eluded medical diagnosis.

Apparently, Rockwell went to great lengths to make sure that his children felt differently about him. Tom Rockwell recalls, "He was a wonderful father, consumed by his work, true, but never too consumed to listen to one of our concerns or problems."

All of the illustrations in this section emphasize relationships between loved ones. They are hung on an imaginary string that takes us through life's rites of passage, beginning with *A Day in the Life of a Girl* (p. 54), a 1952 *Saturday Evening Post* cover. In these cartoonlike panels, Rockwell gives us a keyhole peek into metamorphic adolescence, and it is the painter-storyteller at his best. Calling upon the women in his audience to remember the time when that first special boy came into their lives, Rockwell brings all those old memories back into focus. "Though you told your girlfriends you couldn't stand him," Rockwell seems to be saying, "you were really flattered to think that someone of the opposite sex found you attractive, and the words you put in your diary had the unmistakable pedigree of puppy love."

The plot thickens in the double panel illustration *Before the Date* (opposite). The boy and girl are both older, but still on the same collision course.

We all know that growing up is a mixed bag, and no one captured the pleasure and pain better than Rockwell. "The dance was heavenly and Billy was so handsome in his white sport coat (p. 58), but time got away from us (p. 59) and Dad would be furious."

Just over the horizon, give or take a few years, is the trip to the county clerk's office for a marriage license (p. 60). Rockwell was living in Stockbridge when this 1955 effort was completed. To pose for the painting, he chose an altar-bound couple, Frances Mahoney and John Lahart (the clerk was local merchant Jason Braman). Again Rockwell's picture speaks ten thousand words, giving us colorful details (old roll-top desk, potbellied stove, wall calendar, cat, bronze spittoon) and delightfully revealing nuances (a bored clerk who passes his time by tending to geraniums, a fastidious bride-to-be on tiptoes filling out the application forms, and her solicitious fiancé, who we can be sure opens car doors for his angel and holds the chair for her when she takes a seat—for the moment anyway). Of course, with marriage comes responsibility, and inevitably one of those responsibilities has a good set of lungs, an insatiable appetite and a perpetually wet diaper.

The humor in *The Babysitter* (p. 61) is only equaled by its insight. The harried tender will try every trick in the book to pacify her charge, but it probably will take Mother's footsteps on the front porch to staunch the tearfall.

A responsibility of parenthood is providing security for one's children, and in one of Rockwell's truly magnificent paintings, *Freedom from Fear* (p. 62), he deals with that subject. It is one of a four-part series of illustrations that Rockwell did after hearing President Roosevelt suggest in a 1943 address that freedom of speech, freedom of worship, freedom from want, and freedom from fear were things we were fighting to preserve.

Roosevelt stirred the patriotic fire in Rockwell's soul, and the artist was inspired to make those four freedoms concrete. With his Arlington artist-friend, Mead Schaeffer, he went off to Washington to propose the project to various governmental agencies. It was to be his gift to the war effort. Surprisingly, no one responded enthusiastically and Rockwell came away depressed, until he mentioned his "rejection" to the *Saturday Evening Post*. The editors there thought it was a brilliant idea, and subsequent enthusiasm from their readership and the American public proved their judgment correct. (The four *Freedoms* were credited with helping to sell over $132,000,000 in war bonds.)

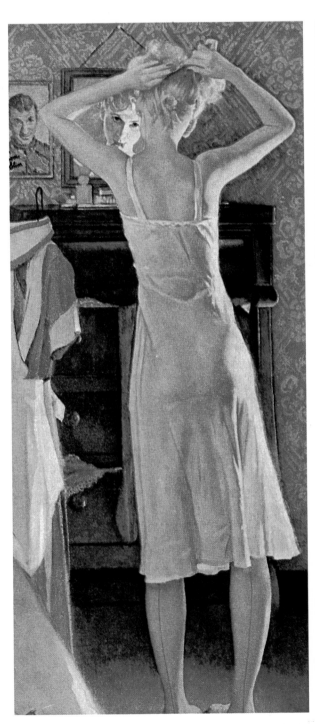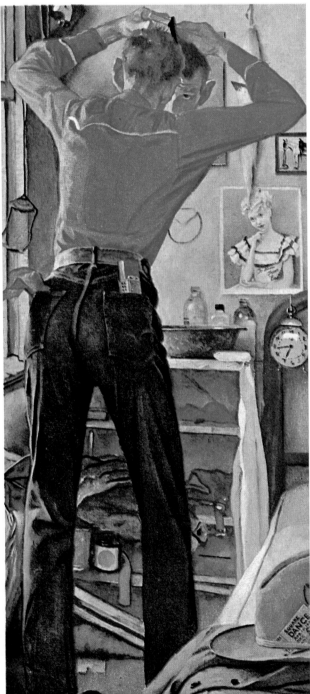

Before the Date, *Post* cover, September 24, 1949

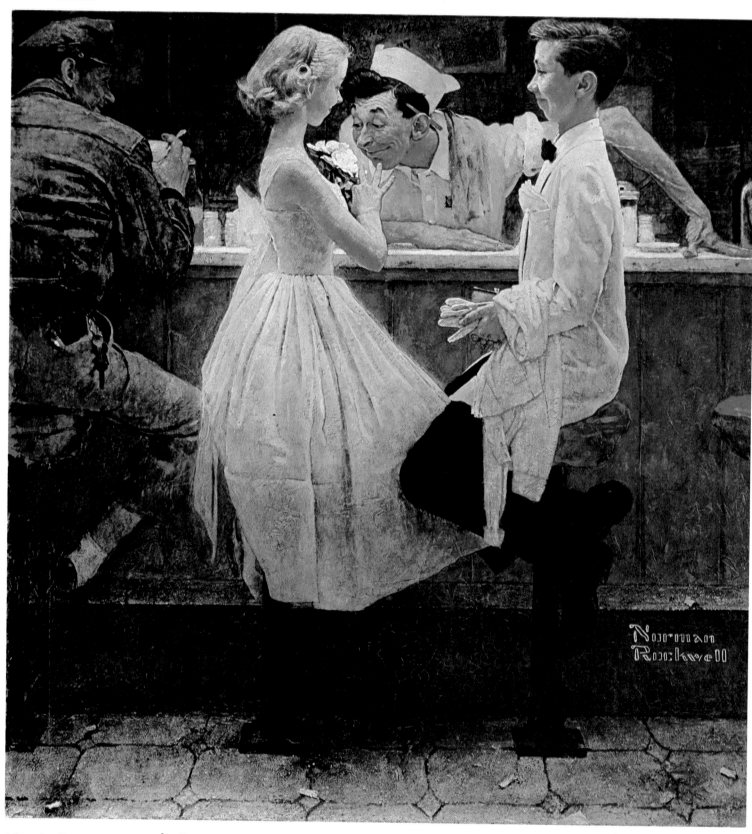

After the Prom, *Post* cover, May 25, 1957

Late Getting Home,
Post cover, March 9, 1935

The Marriage License, *Post* cover, June 11, 1957

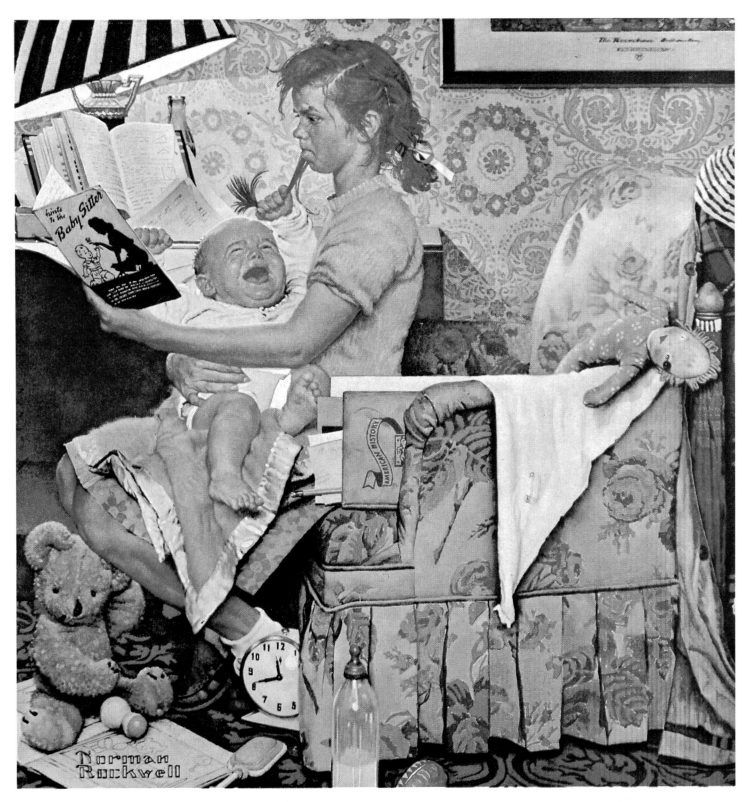

The Babysitter, *Post* cover, November 8, 1947

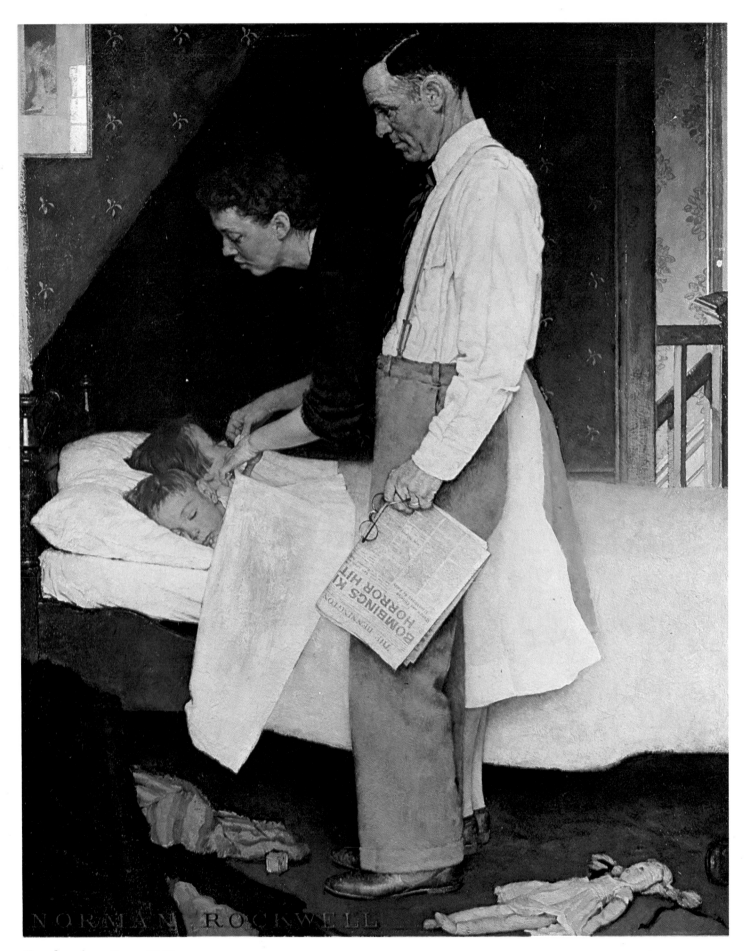

Freedom from Fear, 1943

And little wonder. When viewing *Freedom from Fear,* all parents can identify with this loving pair looking in on their sleeping children. It must be remembered that this illustration was painted against a backdrop of world war, the outcome of which was far from resolved. Bombs were falling on London, and the reverberations were sending shock waves across the Atlantic. A taken-for-granted freedom had been put in jeopardy by a maniacal tyrant, and a nation was gripped by fear.

Simplification can sometimes be genius, and Rockwell gave evidence of it when he reduced the issue to safely sleeping children. Nothing could be more familiar than the simple domestic ritual of tucking in one's children, and nothing more basic in a free society than knowing that their sleep will not be interrupted by gunfire or a terrifying knock on the door. No metaphor could make the artist's point better.

What would a family be without vacations away from home? More rested, someone might jest. In the comic gem *Going and Coming* (p. 64), Rockwell reveals his knowledge about the emotional toll exacted by family outings. Again, Rockwell's powers of observation are uncanny. Note the enthusiasm and anticipation of everyone in the top illustration. Only Grandma seems impassive. Contrast that scene with the one below. Father is wearily bent forward, his cigar as spent as he is. Mother has been overtaken by sleep. The dog is panting and Sis no longer has the breath or inclination to blow prize-winning bubbles. Only Grandma, who has seen it all, remains unbowed.

Going and Coming is an echo of an earlier painting by Rockwell that featured another vacation-weary family (p. 65).

Of course, in any marriage there will be a few moments of disagreement. Sometimes the bone of contention is political, as Rockwell suggested in 1920 when Cox and Harding were vying for the nation's endorsement (p. 66). In 1948, the artist repeated the theme while Dewey and Truman repeated the battle.

Breakfast Conversation, another of Rockwell's domestic invasions, intimates a more subtle kind of bickering (p. 68). Whether the cause of the wife's doleful stare is her newspaper-reading husband or some other marital malady is left to the viewer's imagination.

Once a person becomes addicted to the Rockwellian view of life, he or she begins seeing—in the supermarket, at church, on the playground—all manner of subjects and scenes suitable for the artist's canvas. For instance, not long ago I returned one of my children to college to begin another year. Sitting in my car, I watched a heart-tugging rite of passage outside a freshman dorm. A mother was trying to say goodbye to her daughter, whom I guessed to be a first or only child about to enter her freshman year.

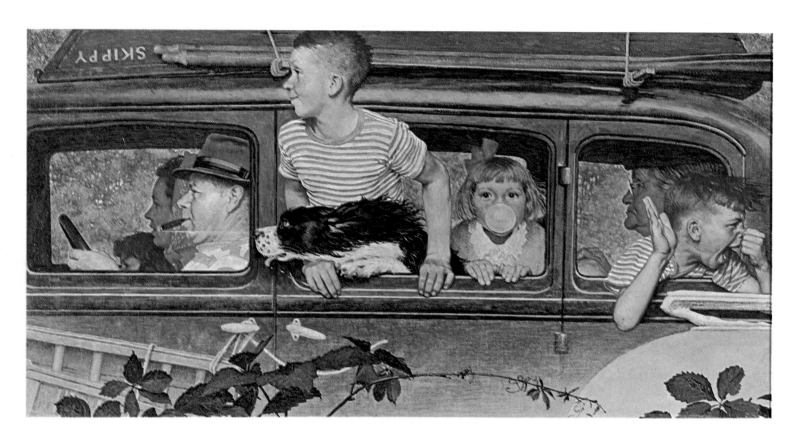

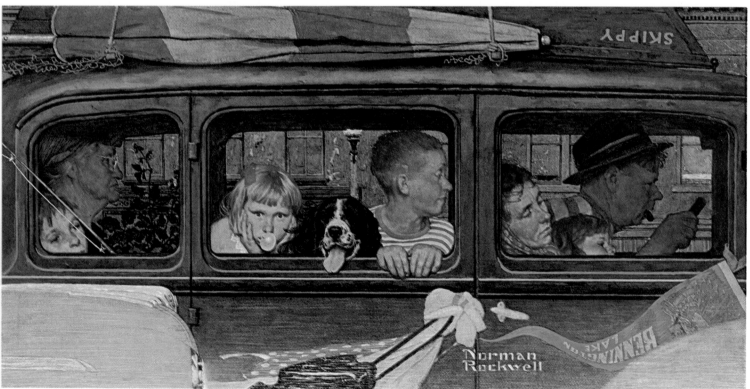

Going and Coming, *Post* cover, August 30, 1947

The Vacationers,
Post cover, September 13, 1930

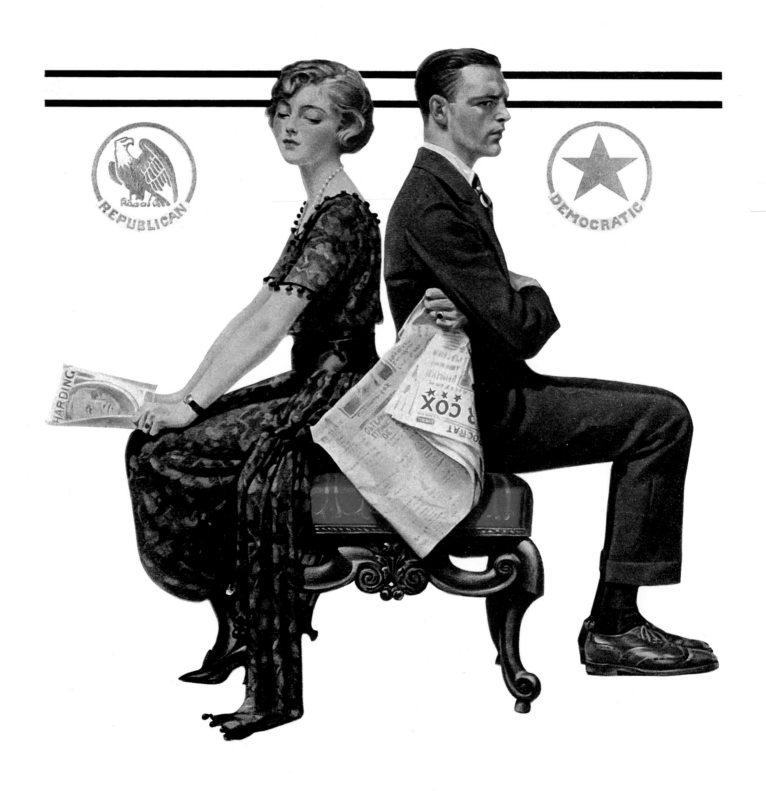

Political Stalemate, *Post* cover, October 9, 1920

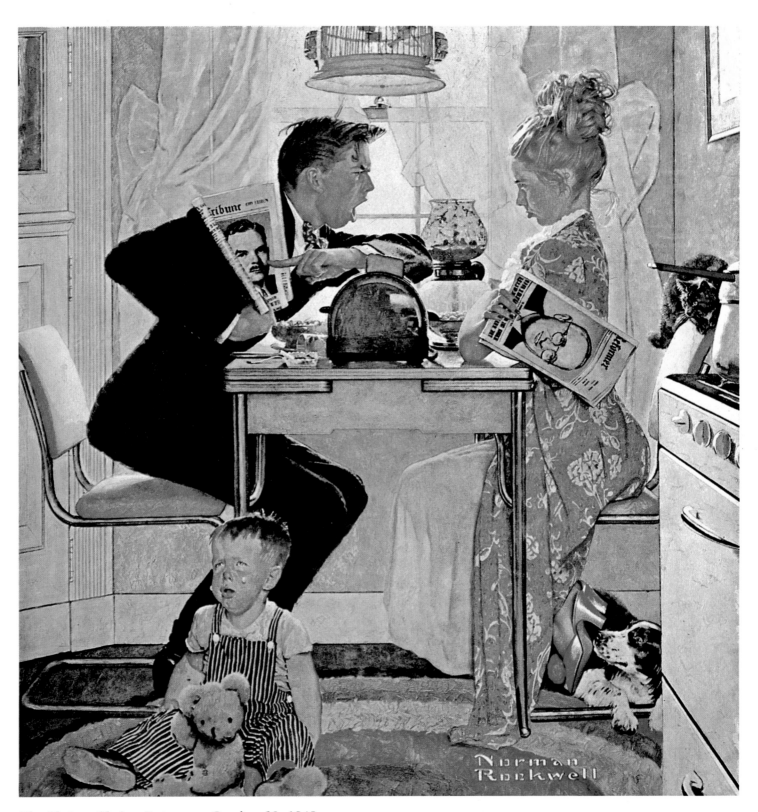

The Obvious Choice, *Post* cover, October 30, 1948

Breakfast Conversation, *Post* cover, August 23, 1930

The mother had helped her child unload her belongings—clothes, alarm clock, stereo, skis, bedspread—and now she reluctantly faced the moment of parting. Oh, such sweet sorrow, leaving behind the little girl she had nursed through the mumps, freckles, acne, braces, her first date. . . . Finally, Mom gave the young woman a squeeze and a peck on the cheek. Still, she small-talked on, postponing the inevitable. When there was nothing more to say, the daughter mercifully cut things short. Throwing her mother a kiss, she ran off like a young filly venturing into a new pasture. Mother waved, biting her lip. Then she got into the car, put her head on the steering wheel and cried unashamedly. Watching the heart-tugging scene, I remembered Rockwell's great painting *Breaking Home Ties* (p. 70), although in Rockwell's story, the characters are male and the scene is a train station. We know it is a small, rural station because the flag and lantern nearby indicate that the approaching train will have to be flagged to stop. Sitting on the running board of an old pickup truck, this parent isn't as voluble as the one I heard. He is uncomfortable, fiddling with two hats, his old worn and soiled one and his son's brand-new one. The rancher-father is no doubt struggling for the right words of counsel for his college-bound offspring. " . . . If you have any problems, call us . . . write your mother every week or she'll get worried . . . if you need more money, let us know. . . . " The son is full of anticipation, anticipation that has spread over the last several days when he bought his new suit and tie and matching argyles. In his hand he holds a lunch Mother fixed and tied with a ribbon. The collie (which belonged to Phyllis Allen of Arlington, remember?), with its head cradled on the boy's knee, seems to be full of melancholy, as if he knows something's up.

All in all, Rockwell gave us an unforgettable painting, one that grabs us by the heartstrings and draws us over the frame and into the picture. That is what Rockwell's art teacher, Thomas Fogarty, once told him to do when painting. "Step over the frame, Norman," he advised, "over the frame and live in the picture."

The cycle goes around and around—from college to jobs, on to marriage, and children and grandchildren, the latter a subject Rockwell never tired of painting. To his credit, the child inside him never grew wrinkled with age and for that reason Rockwell was forever able to capture on canvas those happy, carefree summer days he as a youngster spent away from the city. How he seemed to enjoy juxtaposing old and young as they play at some childhood pastime—fishing at the old creek or ice skating or playing ball or kite flying.

The illustration (p. 71) of the grandfather and grandson engaged in flying kites reminded me of this long-ago experience I set to verse:

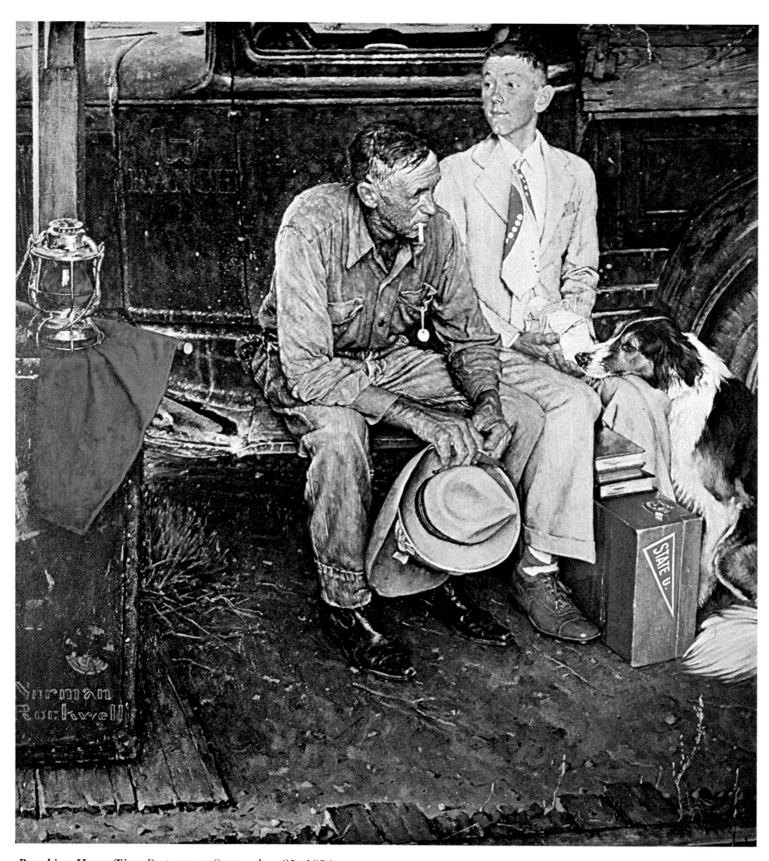

Breaking Home Ties, *Post* cover, September 25, 1954

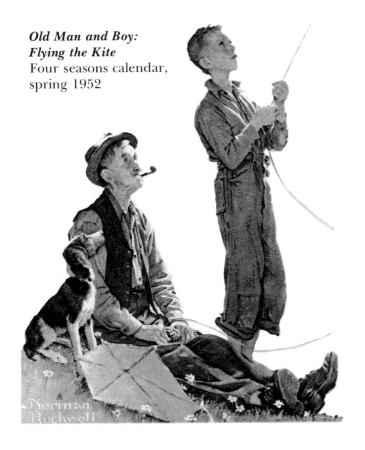

Old Man and Boy:
Flying the Kite
Four seasons calendar,
spring 1952

Son Steve clings to an empty string
 or so it seems,
He says his kite's out there—
 he's full of dreams,
Frowning at the Cape Cod fog
 which drips on me,
I fail to find even tail
 in that sky sea.

"Here take hold of the string," he says,
 "you can feel it."
Sure enough like fishing tight line
 the wind just bit.
Then I stand back and watch him feed
 the clouds more string,
A passerby smirks as if to say,
 such a fool thing.

"Give him the cord son," I whisper
 to ears tuned out.
His mind is on higher things.
 I'd have to shout.
Would that I could always embrace
 The Higher Thing.
And in all life's fogs trust childlike
 a piece of string.

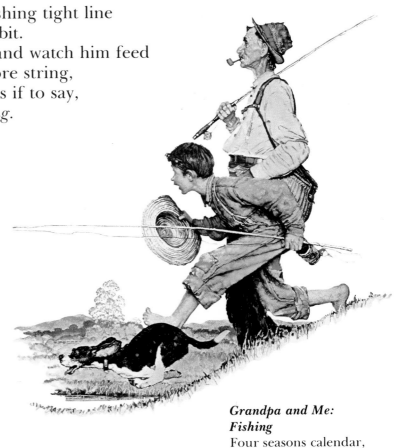

Grandpa and Me:
Fishing
Four seasons calendar,
spring 1948

3. FAITH IN OUR HOPES AND DREAMS

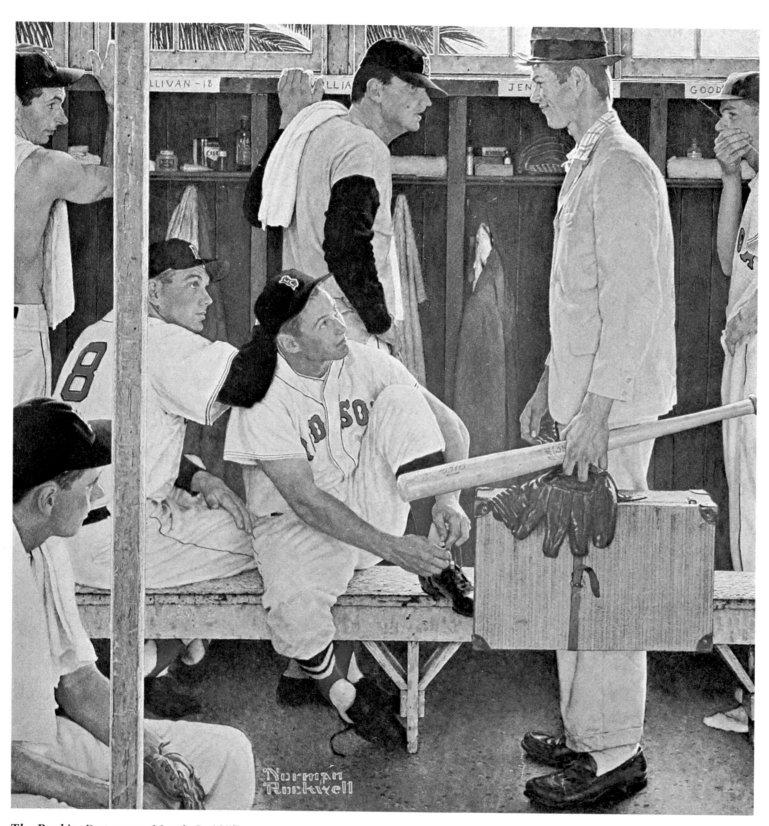

The Rookie, *Post* cover, March 2, 1957

One frosty March morning in 1916, a very skinny, very scared 22-year-old man from New Rochelle boarded a train in New York's Penn Station for Philadelphia. With him, he carried an unwieldy suitcase, 30 by 40 inches by one foot. It had been fashioned out of black leather by a harnessmaker to protect the paintings the man had carefully prepared to show the editor of the *Saturday Evening Post*. (One observer asked him facetiously if there were a corpse inside.)

The artist had made no appointment with the famous George Horace Lorimer, fearing he'd be told not to come. But the art director, Walter M. Dower, greeted the visitor cordially and without ado took his two finished paintings and three sketches off to show Mr. Lorimer.

In a few minutes, Mr. Dower returned and informed the hopeful artist that the editor liked them all. The *Post* would pay him $75 each for the paintings and wanted him to go ahead with the three roughs—all for covers of America's most popular magazine, which at that time had two million subscribers. The dumbfounded artist could hardly believe his ears.

Thus began the celebrated association between Norman Rockwell and the *Saturday Evening Post*—a liaison that spanned six decades and resulted in over 300 cover illustrations.

Because Norman Rockwell had a modest beginning, because he was spindly of build and not particularly handsome—the first writer ever to interview him had told him bluntly, "Norman, you have the eyes of an angel and the neck of a chicken"—and because he had lots of self-doubts about his talent, he was a lifelong advocate of the underdog. He understood how it felt to be picked last when the boys were choosing up sides for a ballgame, how it felt to wear last year's too-short trousers, how it felt to be impaled on a critic's pen or be bypassed entirely when accolades were being given.

Once he was to be honored along with other noted artists at a big banquet. Inviting many of his friends to attend, Rockwell took his place on the dais awaiting his moment in the spotlight. Alas, it never came. The master of ceremonies inadvertently skipped over him and

Rockwell went unhailed, a humiliation he never forgot. Is it any wonder the man could paint the Walter Mitty dreamers of the world with such penetrating accuracy?

Does one have any doubts that the rookie baseball player (p. 74) in the Boston Red Sox locker room (can you pick out Ted Williams and Jackie Jensen in the drawing?) will make the team and hit a crucial home run? Or that Dolores and Eddie of the Gaiety Dance Team (p. 78) will find the fare to get to their next date, which will eventually land them a week at the Palace?

Sometimes Rockwell carried his subjects' dreams to fruition, as he did with his 1967 drawing of Neil Armstrong walking on the moon (p. 80). Its 1927 parallel was a hero-looking-off-into-the-wild-blue-yonder illustration of Charles Lindbergh, following his historic flight.

But more often than not the dreams of Rockwell's subjects are left in limbo. We don't know whether or not his *Courting Couple at Midnight* (p. 79), breathlessly in love, will make it to the altar or not. We don't know whether the children moving into a new neighborhood (pp. 82–83) in a 1967 *Look* illustration will make the transition successfully or not.

Most of Rockwell's illustrations deal with smaller themes, mundane aspirations. Will the guys putting up the television antenna (p. 84) in 1952 get a picture before the ballgame is over? (If not, how about the Ed Sullivan Show, Milton Berle, or the Gorgeous George–Nature Boy wrestling match?) Will the dashed dream of the boy who learned the truth about Santa (p. 85) be repaired in time for him to fully appreciate next Christmas? Will the wife convince her husband that new drapes at $20 a panel will turn the living room into a candidate for *Better Homes and Gardens* (p. 86)? Will the heart-broken lass who tragically has missed the Spring Hop (p. 87) recover from her cold in time for the Junior-Senior Prom?

Sometimes Rockwell left his audience pondering the hopes and dreams of his subjects—like those of the theater-cleaning charwomen (p. 88). What wishes do they still harbor? What visions do they still entertain? In what roles would they cast themselves, Rockwell may be asking reflectively, if they had the power to go back to Act I and start the play all over again?

Home Duty, *Post* cover, May 20, 1916

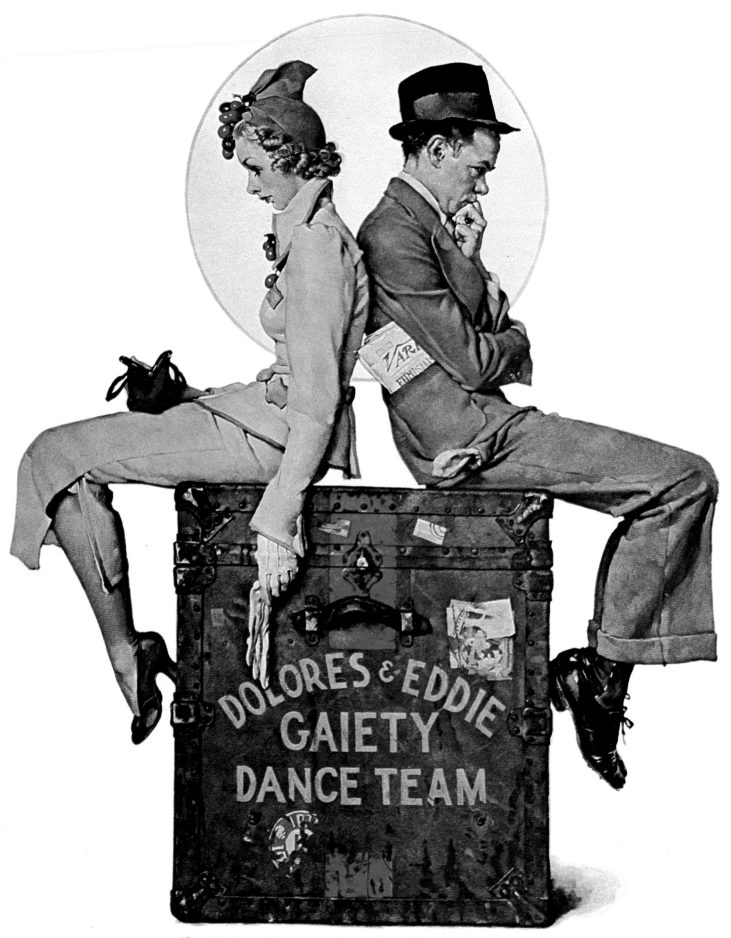

Show Business, *Post* cover, June 12, 1937

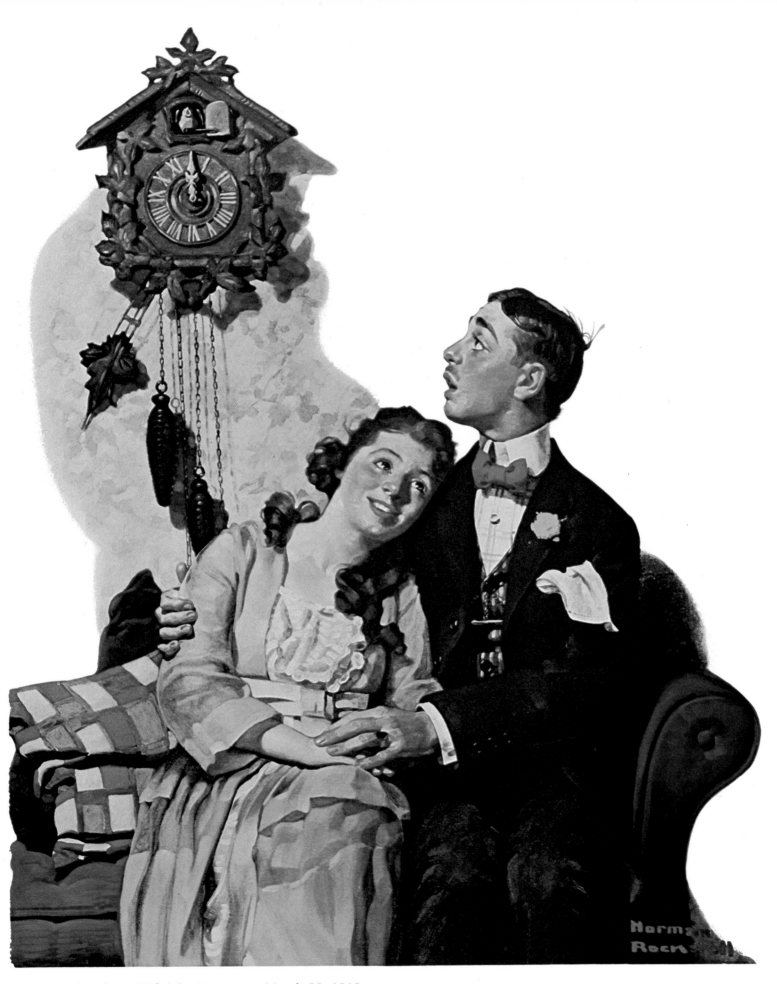

Courting Couple at Midnight, *Post* cover, March 22, 1919

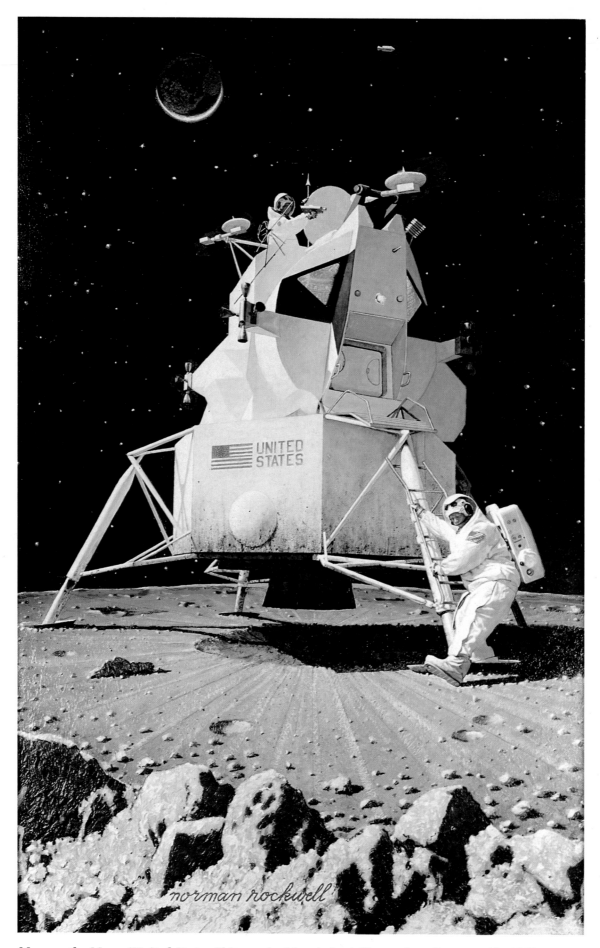

Man on the Moon (United States Ship on the Moon), *Look* illustration, January 10, 1967

Lindbergh, Post cover, July 23, 1927

New Kids in the Neighborhood, *Look* illustration, May 16, 1967

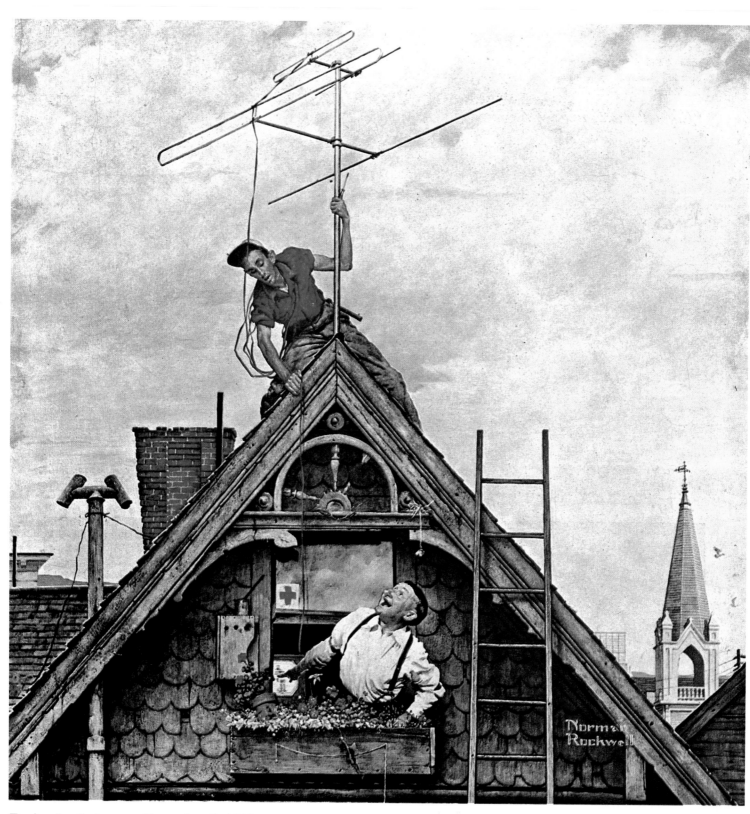

Tuning In, *Post* cover, November 5, 1949

84

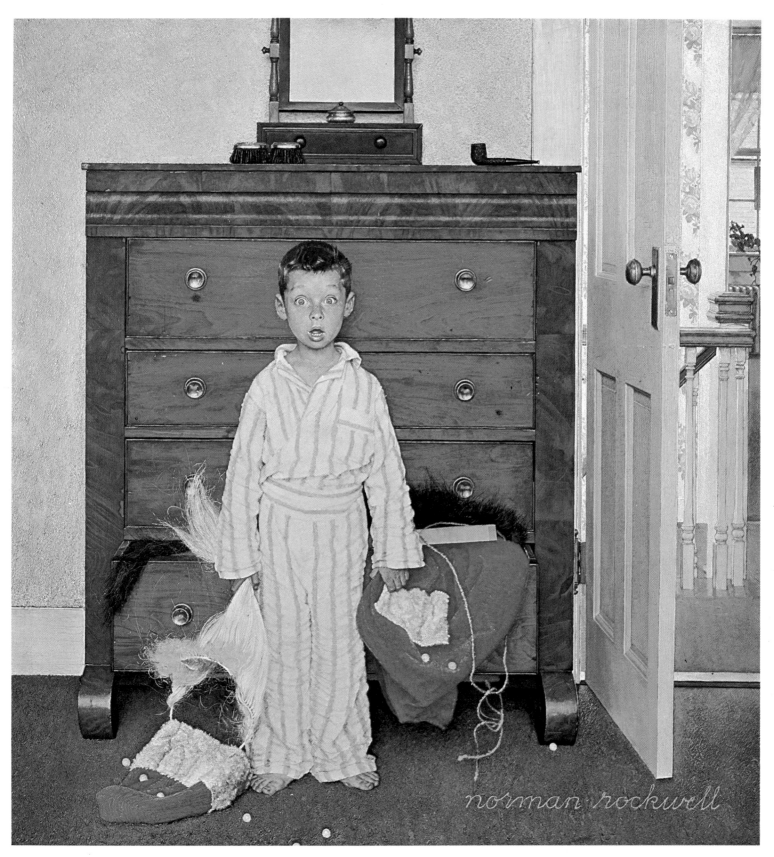

The Discovery, *Post* cover, December 29, 1956

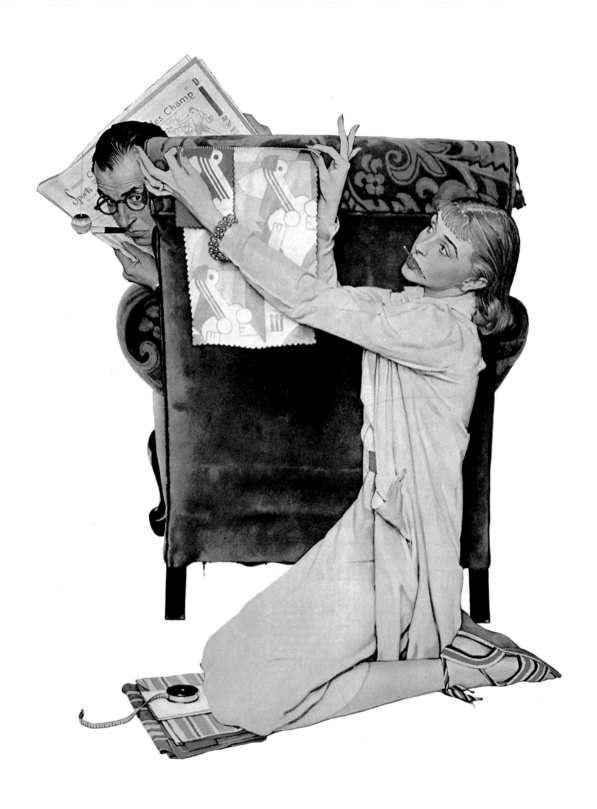

The Decorator, Post cover, March 30, 1940

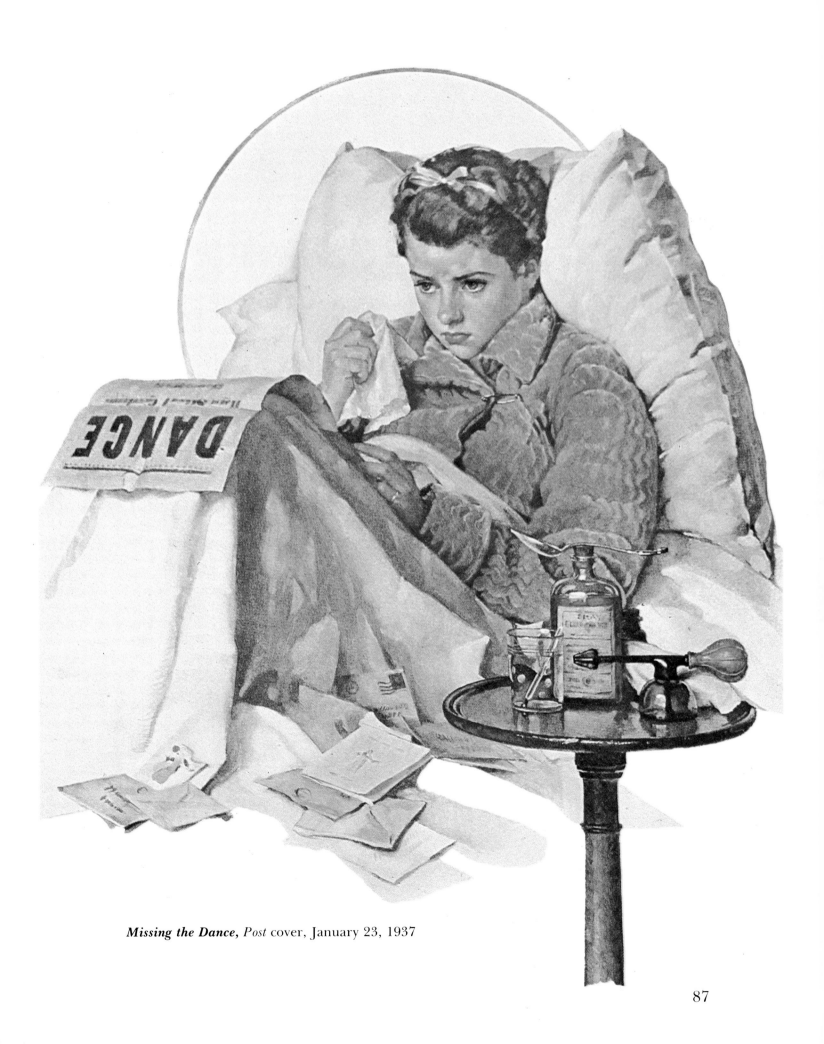

Missing the Dance, *Post* cover, January 23, 1937

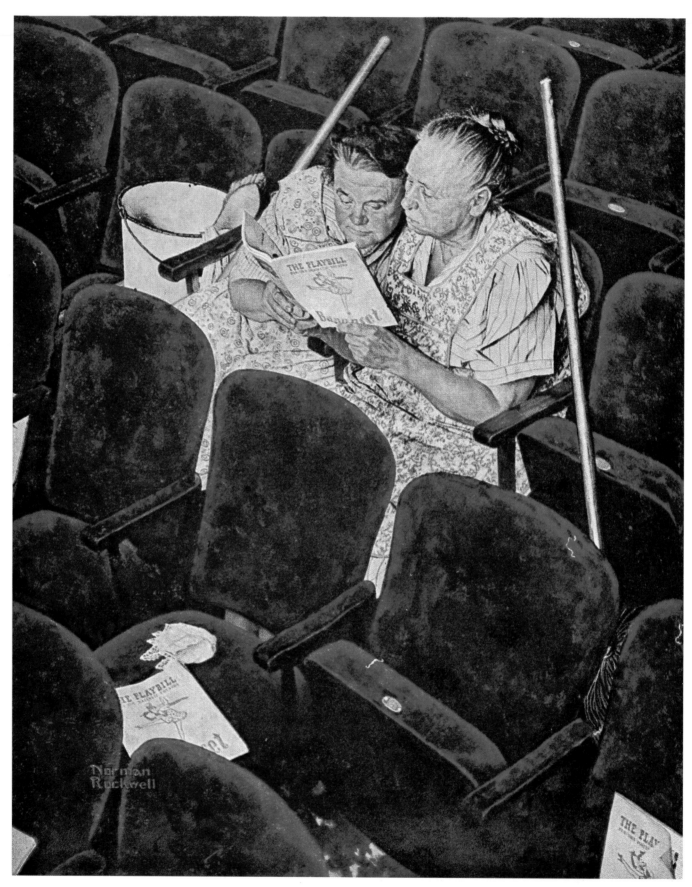

The Charwomen, *Post* cover, April 6, 1946

4. FAITH IN OUR TRADITIONS

Fishing Lesson, Post cover, August 3, 1929

When Norman Rockwell's creativity seemed to dry up and he was struggling for *Saturday Evening Post* cover ideas, he often resorted to "pump priming," something common among writers and artists. Instead of sitting idle, waiting for the muse to fill his fallow mind, Rockwell would busy himself drawing. He said a lamppost was often his starting point. ("I got to be the best lamppost artist in America.") Then he would draw a sailor leaning against the lamp. Next, he'd imagine a story about the character. Maybe the sailor was lost, far from home, lonely. Through this technique he started the wheels turning, and from such mechanizations he would eventually hit upon an illustratable idea.

But that was only Step 1. Next in the sequence was doing sketches, which he then carried to Philadelphia for the purpose of selling Mr. Lorimer (or later art editor Ken Stuart) on their merits.

In his autobiography, Rockwell said that the iron-fisted Mr. Lorimer would never accept more than three of his ideas on any one visit, so he usually included a couple of "throwaways" for the editor to reject. Rockwell explained that he "acted out" each sketch, and that his favorites got Academy-Award-worthy dramatizations, right down to the smirk on the boy's face and the bowlegged walk of the old cowboy.

The calendar proved to be Rockwell's best friend when ideas were scant, and he often resorted to seasonal settings for his carefree grandpas, freckle-faced boys, and spotted-mutt dogs. Such traditions as spring fishing (opposite), summer visits to the old swimming hole (p. 93), fall leaf raking (p. 94), and winter ice skating (p. 95) proved apt subjects for the *Saturday Evening Post.* All that he needed to flesh out one of those old "sugar sticks" was a fresh story line. Of course, that is always the rub for creators—finding a new twist to an old theme. Still Rockwell produced more consistently than any other *Post* contributor, forever finding visual bon mots for his illustrations.

No date on the calendar proved more productive for him than December 25. One of my favorite Christmas illustrations is *The Railway Station* (p. 96), painted in 1944. In Arthur L. Guptill's fine book *Norman Rockwell, Illustrator,* the artist tells how he came to do that painting. Believing that a wartime railroad station at Christmas would

prove heartwarming, Rockwell stopped off in Chicago on a trip to California and in the North Western Railroad Station had pictures taken from a high ladder set up in the middle of the waiting room. Though there were several genuine reunions taking place, no one in the station was coming home for Christmas since the pictures were taken in July. But the travelers were very cooperative, agreeing to play-act with total strangers, even going so far as to embrace and kiss unknowns for Rockwell's benefit. One request for an embrace between the redhead in the white coat and the Navy officer brought particularly enthusiastic compliance. Then Rockwell discovered why. The couple explained that they were husband and wife!

Back in his studio, Rockwell had to add the holiday touches to the station, put gaily wrapped packages in the hands of the travelers and recostume them all, adding darker winter dresses and suits, scarves, furs, and gloves. (Like the old story of the art director who asked an artist to make only one change in his illustration showing thousands of football spectators: "Could you move all their heads a little to the left?")

Another favorite Christmas cover of Rockwell's featured a more intimate reunion (p. 97), but conveyed the same deep feelings of affection brought on by this annual migration. In it Rockwell painted himself, his wife Mary doing the embracing, his sons, and many of his friends and neighbors, among them Grandma Moses (at left).

Right next door to Christmas is New Year's Eve, and Rockwell found many excuses to paint the threshold of another year. None of them was more successful than his illustration of the waiter facing the mess left by party-goers (p. 98). With shoulders drooping and pick-up platter at his side, the tired Waldorf Astoria cleanup man surveys the confetti and streamers not with celebratory delight but with "where do I begin?" resignation. Once again, we see Rockwell putting himself in the place of the common man and commiserating with his life of "quiet desperation," as Thoreau put it. (Remember, Rockwell was the one who swept out the Grange hall before square dances.)

Any and all traditions were malleable clay in Rockwell's hands. Barbershop quartet singing (p. 101), an American institution, got a huzza from Rockwell in 1936, as did chamber music in the back of *Shuffleton's Barbershop* (p. 100), the now-extinct West Arlington emporium of conversation and culture. The elaborate details of the painting seen from the street through the shop's front window—past magazine rack, woodburning stove, barber chair and folded towel, shaving mugs and broom—is Rockwell par excellence. I can almost smell the witch hazel.

Traditional observances such as the Fourth of July received Rock-

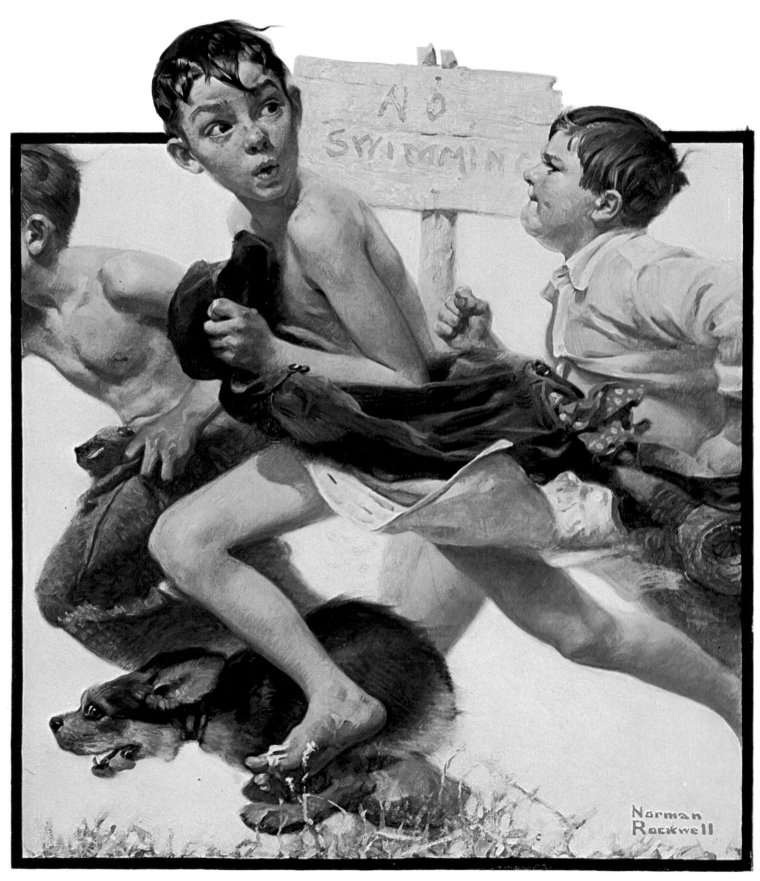

No Swimming, *Post* cover, June 4, 1921

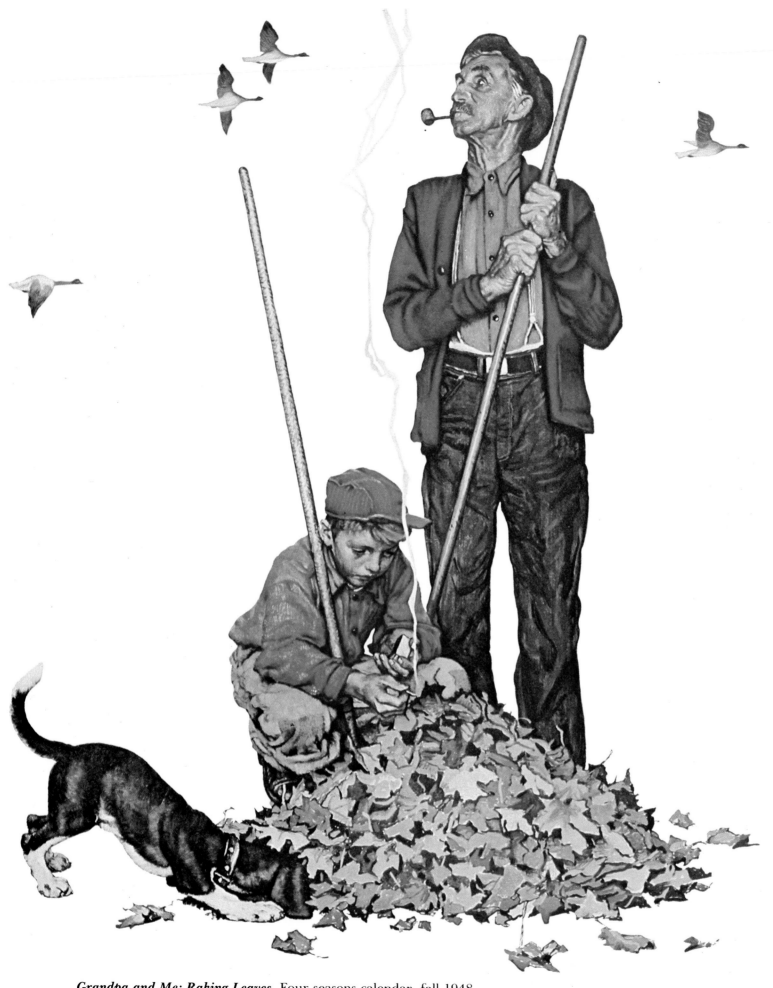

Grandpa and Me: Raking Leaves, Four seasons calendar, fall 1948

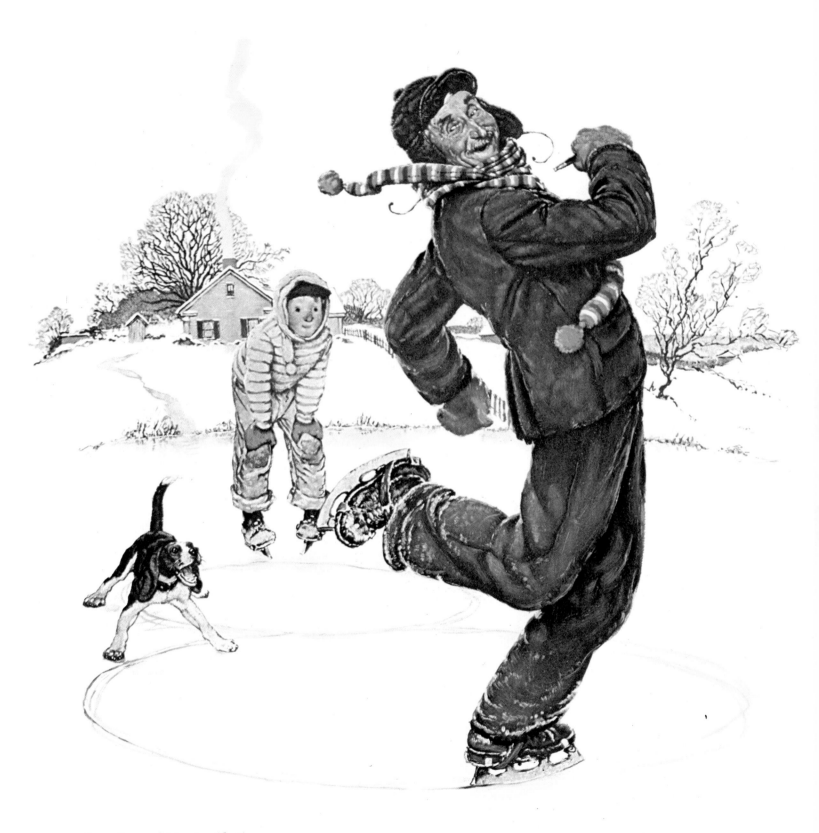

Grandpa and Me: Ice Skating
Four seasons calendar, winter 1948

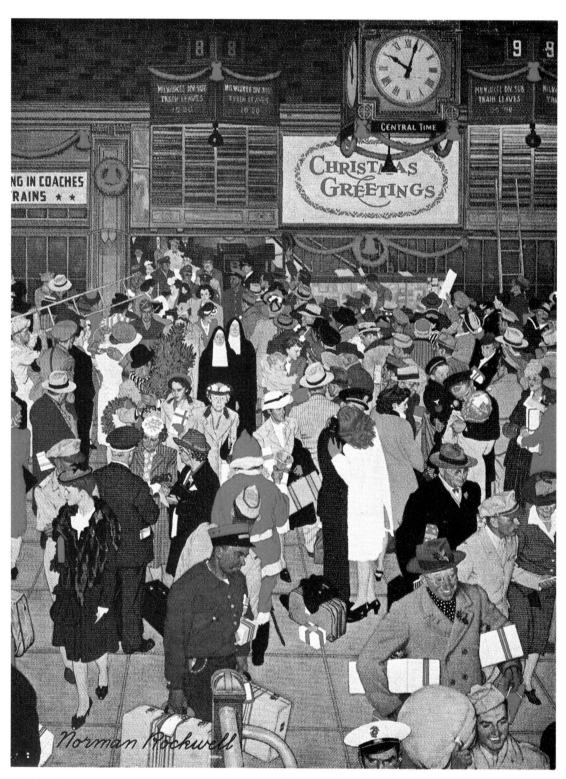

The Railway Station, *Post* cover, December 23, 1944

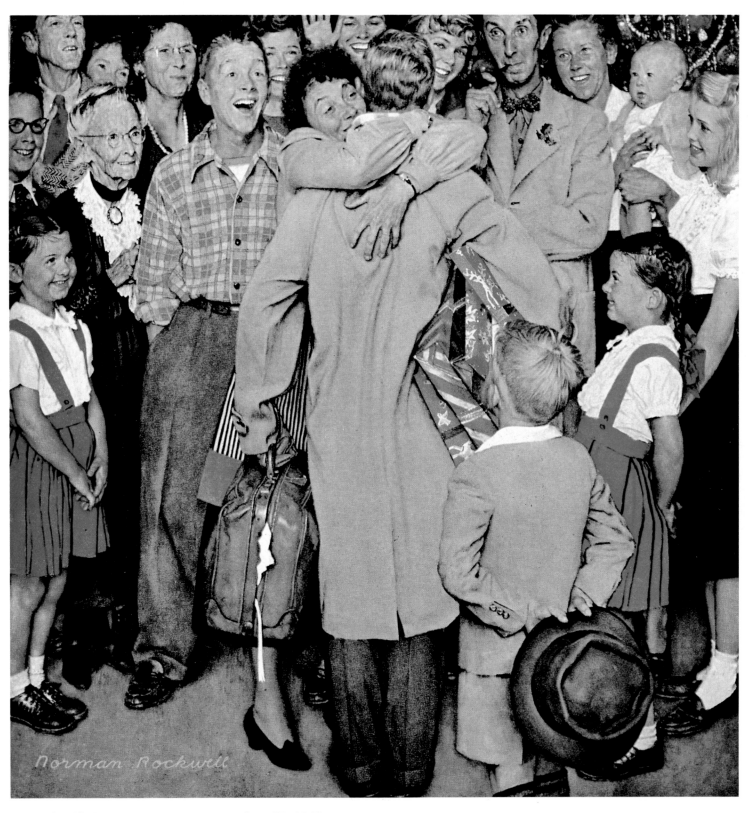

Home for Christmas, *Post* cover, December 25, 1948

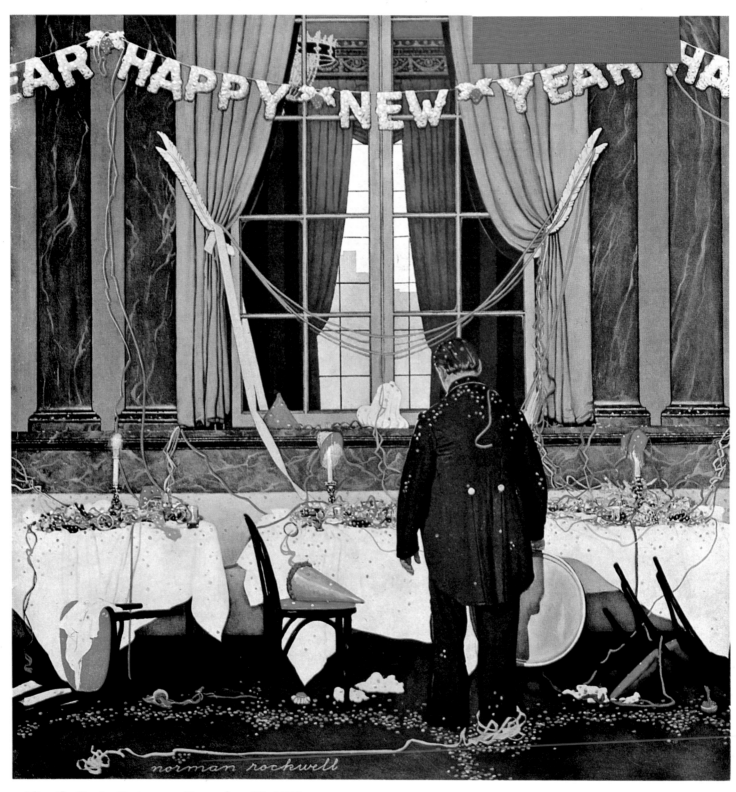

After the Party, *Post* cover, December 29, 1945

well's attention on several occasions, once resulting in a bow to Ben Franklin (p. 102), who among other things founded the magazine for whom the artist toiled so faithfully. Another red-letter date in years past was March 15 (income tax deadline), and although dollarwise it may have been less painful then, Rockwell's sympathetic illustration of the harried taxpayer (p. 103) suggests that the price was always blood, sweat, and tears. Quadrennially, November means a U.S. Presidential election, and Rockwell seldom let the event pass without painting it—as in 1944, when he depicted a voter still trying at the last minute to choose between the candidates (p. 104).

The illustration of Aunt Polly plying Tom Sawyer with a huge spoonful of castor oil (p. 105) marks an annual spring ritual in the minds of many of us past 40. But not all about the coming of warm weather is distasteful, Rockwell reminds us. There's baseball—if it doesn't rain (p. 105). Again, Rockwell, by supplying all the particulars, gives us a story within a story. The scene is old, long-gone Ebbetts Field. Rain has come, and umpires Larry Gaetz, Beans Reardon, and Lou Jorda are trying to decide whether or not to continue play. In the background, Pittsburgh Manager Billy Meyer appears to be praying, while Brooklyn's Clyde Sukeforth seems elated, pointing to the sky. The scoreboard tells why.

Or does it? If the game is called at this point it will be declared a five-inning, 1-0 victory for Pittsburgh. Then why is the Brooklyn coach so pleased with the turn of events? Does he perceive a clearing sky that will allow the game to continue and give the Dodgers another chance? It is the only explanation. Otherwise, Rockwell painted the scene backward and should be charged by the official scorer with an error.

The sports calendar provided Rockwell with several other memorable *Post* covers, including *The Dugout* (p. 106), which captured the futility of Jolly Charlie Grimm's Chicago Cubs in the summer of 1948. With fall comes football, not only for the pros, but for thousands of high school teams across the country (p. 106). And when the snow flies and athletes come indoors, interest turns to basketball (p. 107), which, like all sports, has an equal number of winners and losers.

A competitive tradition of a different form is practiced in the barnyards of the nation, where kids in 4-H clubs tend to farm animals—combing and currying, anointing and pedicuring them in hopes of garnering a blue ribbon at the county fair. In *County Agriculture Agent* (pp. 108–109) Rockwell captures the preparation with the proper respect such important happenings deserve. Here, the artist shows he understands the discipline and commitment and teamwork

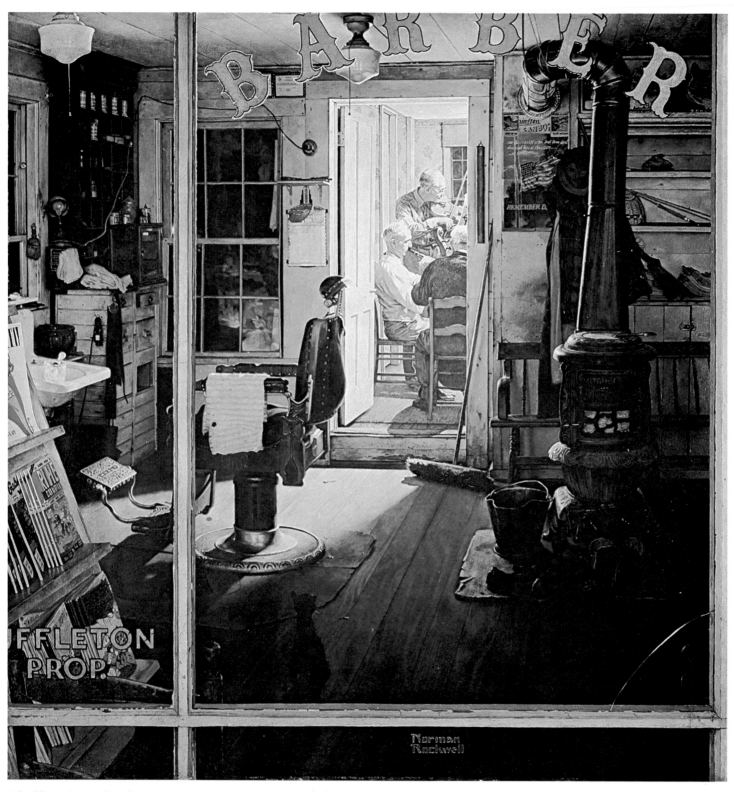

Shuffleton's Barbershop, *Post* cover, April 29, 1950

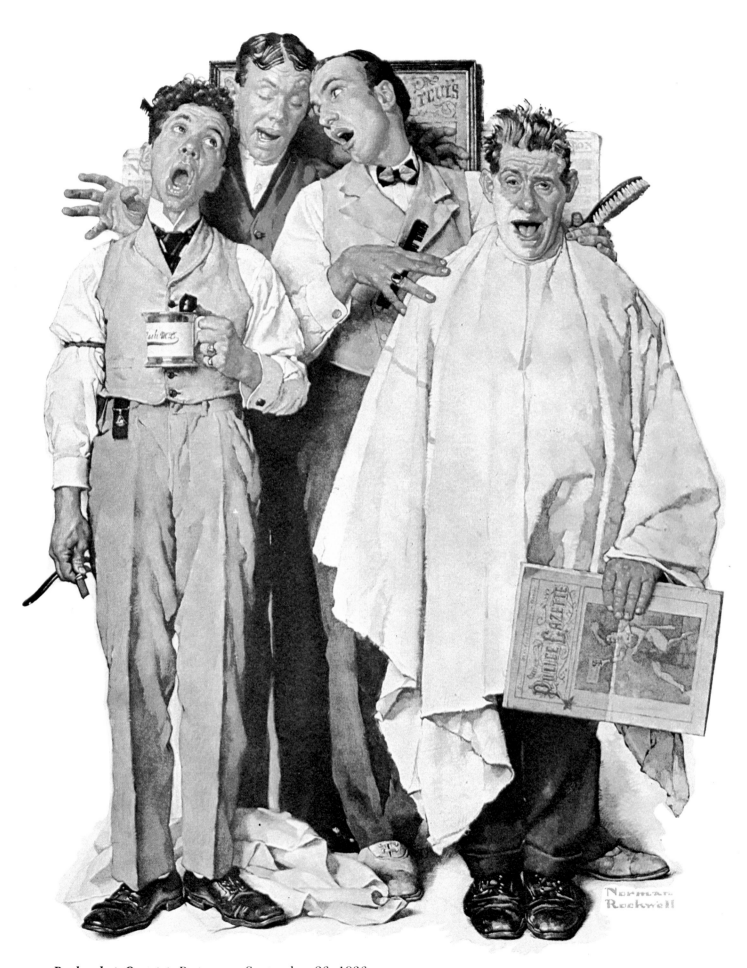

Barbershop Quartet, *Post* cover, September 26, 1936

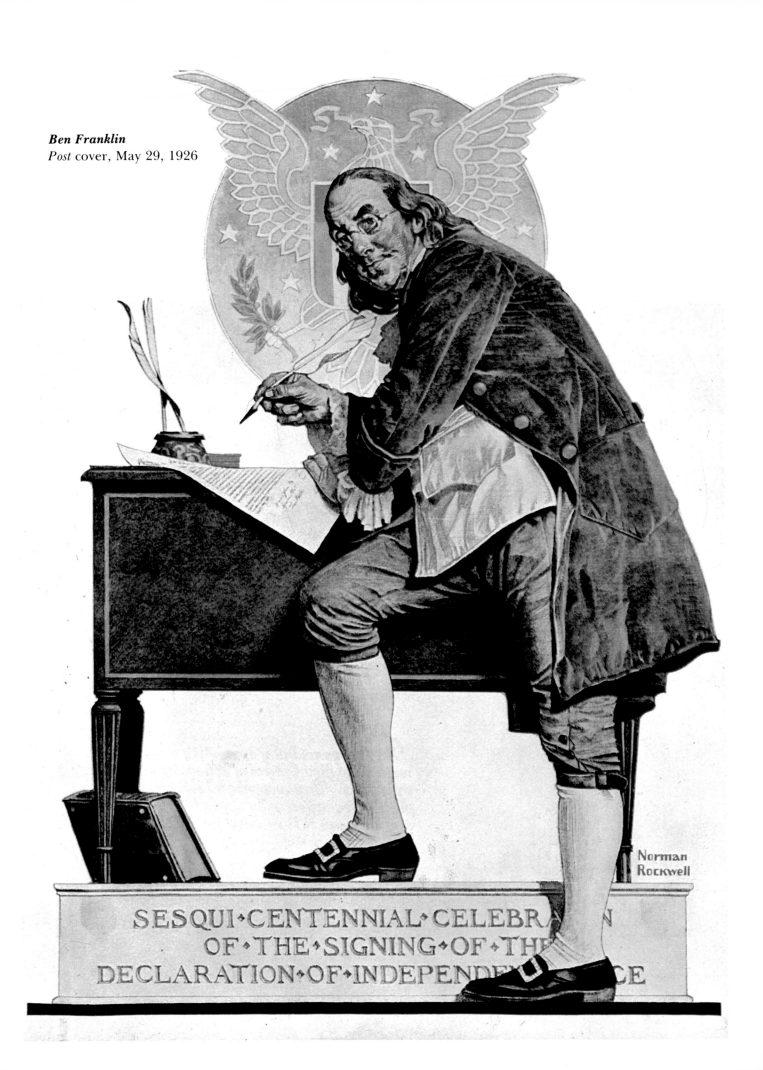

Ben Franklin
Post cover, May 29, 1926

SESQUI·CENTENNIAL·CELEBRATION
OF·THE·SIGNING·OF·THE
DECLARATION·OF·INDEPENDENCE

Tax Deadline, Post cover, March 17, 1945

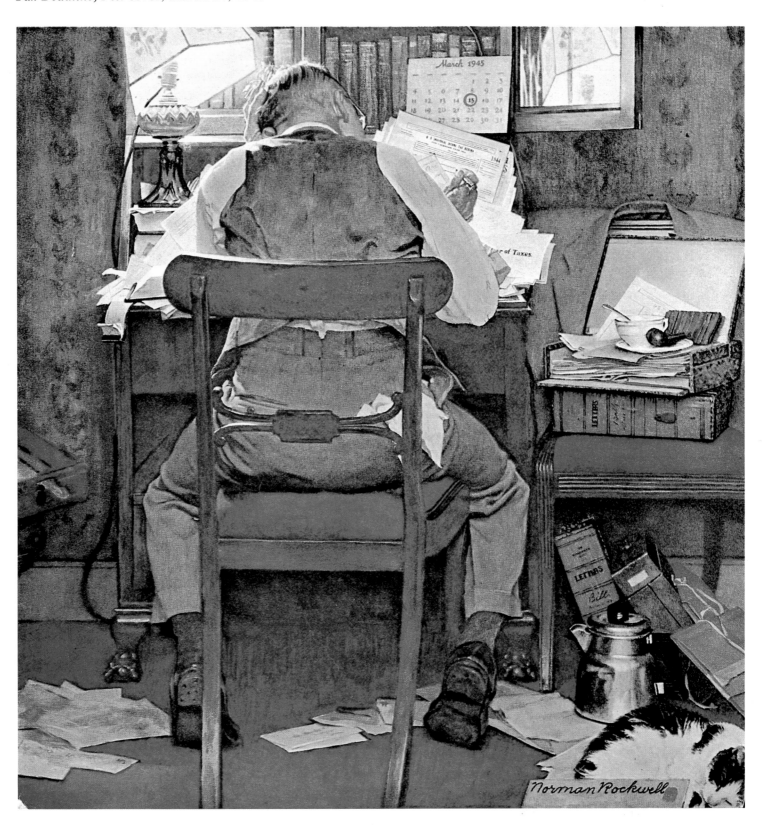

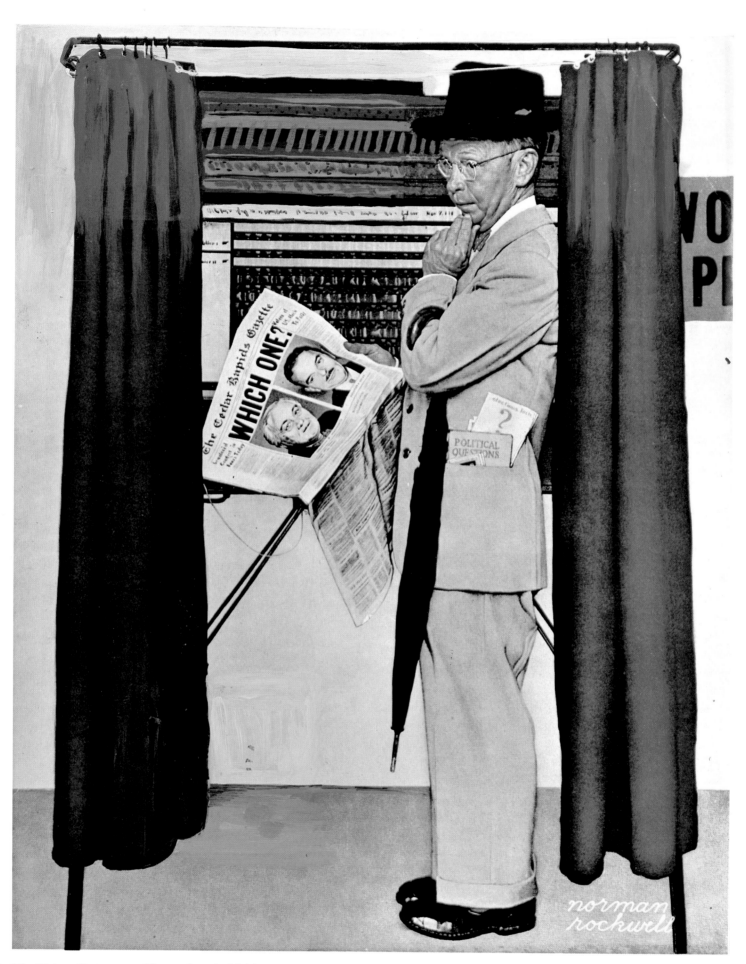

The Voter, Post cover, November 4, 1944

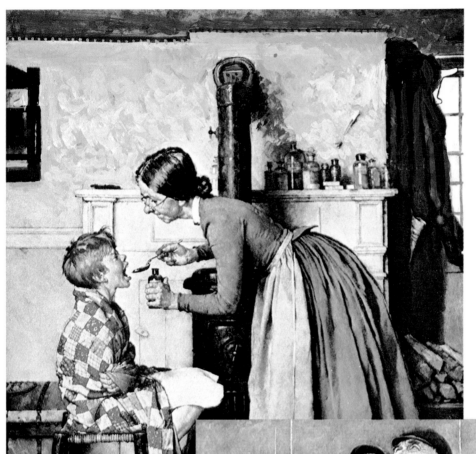

Spring Tonic
Post cover, May 30, 1936

Bottom of the Sixth
Post cover, April 23, 1949

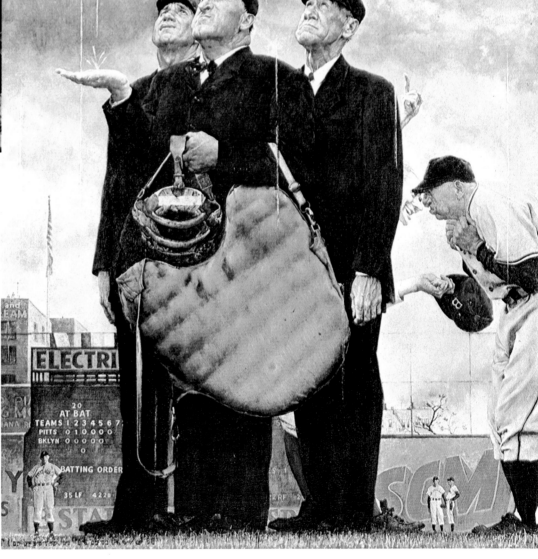

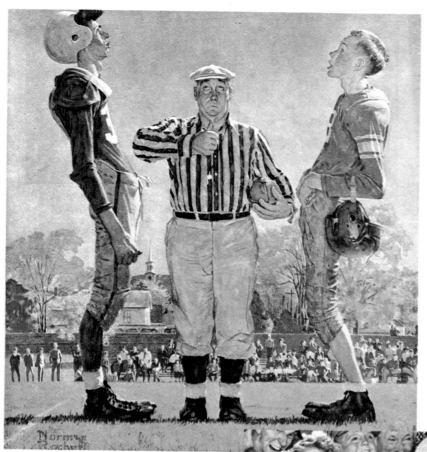

The Coin Toss
Post cover, October 21, 1950

The Dugout
Post cover, September 4, 1948

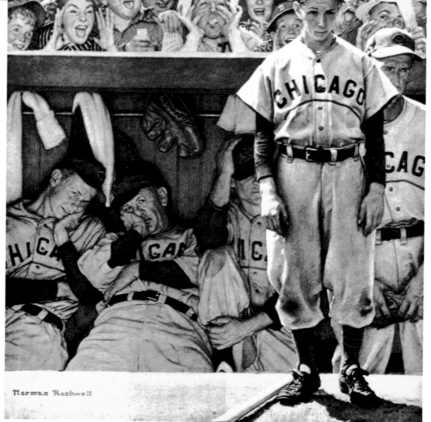

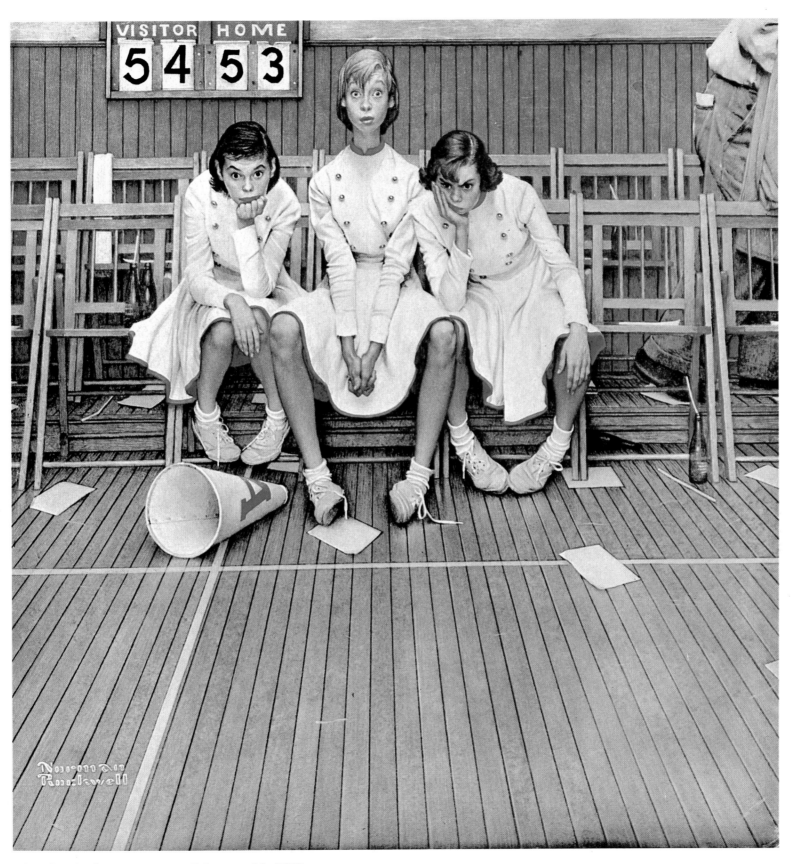

The Cheerleaders, *Post* cover, February 16, 1952

such a family and community undertaking requires. There are
judges, agriculture and home-ec teachers, and 4-H leaders behind the
scenes, in addition to county agents who help with the preparations.
Note the interest of all in Sis's calf—Dad, Gramps, or maybe the
hired man, her brother, and another sister with Mom, who we can be
sure has been given advice on the sewing project her daughter holds
and will be entering at the fair. Even the horse and a passing chicken
can't take their eyes off the excitement. (Rockwell was an experienced
painter of chickens. Once he explained that he could get one to pose
for four or five minutes by rocking it back and forth.)

But in a twinkling of an eye county fairs will be over, harvest
time will come and Thanksgiving will be upon us, when we pause like

the generations before us to give thanks for manifold blessings from our heavenly Father. Families will gather and celebrate, each according to their own traditions. Though Rockwell painted many paeans of thanksgiving, none is more often reproduced than *Freedom from Want* (p. 110), an illustration that captures the flavor, strength, and love of the American family like few others. What is more traditional about our way of life than coming together at a familiar time, in a familiar place, to reminisce with parents and grandparents, kids, grandkids, aunts and uncles, nieces and nephews, the whole clan, in one happy cacophony of clattering dishes, unabashed laughter, and animated conversation that lasts long into the night?

Freedom from Want, 1943

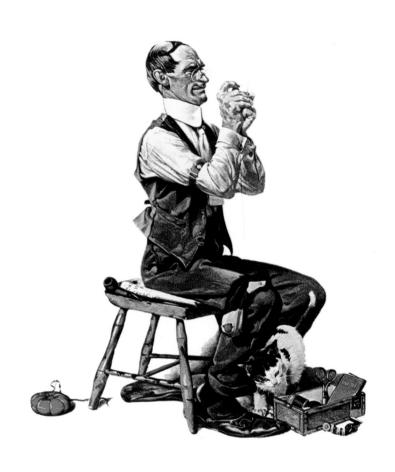

5. FAITH IN OURSELVES

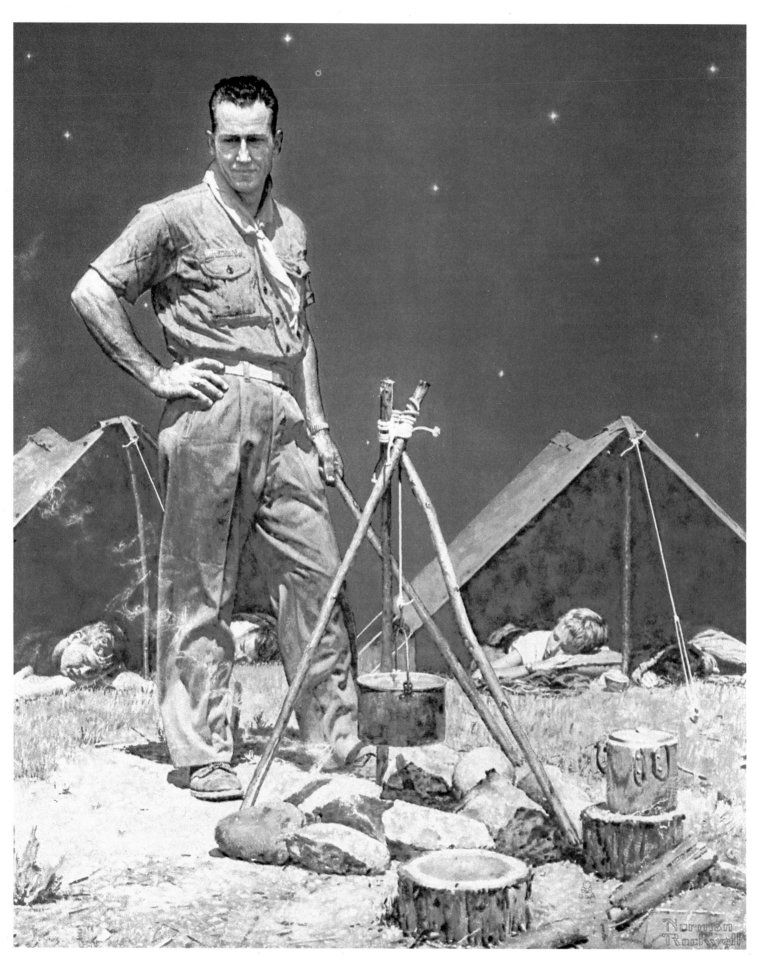

The Scoutmaster, Boy Scout calendar, 1956

O ne of the character traits of the people who first settled on our shores was that they possessed a strong faith in themselves. And like toughened north-side-of-the-mountain trees, this pioneering spirit, this independence, this self-confidence helped steel them against all manner of life-threatening contingencies.

That isn't to say that God was not considered a partner in their destiny—they daily sought His guidance and blessing—but in practical matters of survival they knew ultimate responsibility rested with the individual. St. Augustine's philosophy was theirs: Pray as if everything depends upon God; work as if everything depends upon you.

Stated another way, their sentiments were not unlike the man who took over an old woebegone farm, forfeited to the elements by its former owner. Laboriously, the new landowner toiled for months repairing the house, barn and fences. When spring came, he plowed and planted and tilled his ripening crops. Then one day the local minister came by. Surveying the tremendous improvement, the pastor exclaimed, "The Lord and you have done wonderfully!" "Yes, I reckon you could say that," the farmer answered, "but the Lord sure wasn't doing very well when he was running it by himself."

Norman Rockwell was blessed with a strong streak of self-sufficiency, too, realizing early that there was no free lunch, and if he were to accomplish anything, he would have to do it himself.

About his only chance of success he figured was in drawing pictures, a talent that surfaced early in his life. Rockwell's maternal grandfather, Howard Hill, had been an artist before him. Hill's forte was painting people's pets in accurate, picturelike, finely detailed drawings, from which he made enough to support a "cheaper by the dozen" family.

Maybe Norman inherited some of his grandfather's ability; all he knew was that art was the only area in which he shone, and so at 15, he dropped out of Mamaroneck High School and enrolled in the National Academy in New York.

"My ability was just something I had, like a bag of lemon drops," Rockwell once explained. "Jarvis [his brother] could jump over three orange crates; Jack Outwater had an uncle who had seen pirates; George Dugan could wiggle his ears; I could draw."

From the beginning there was no question that he was good; he worked hard at his calling and he succeeded. From the Christmas cards he was commissioned to do for Mrs. Arnold Constable at age 16, to art editor of *Boy's Life* at 19, to cover illustrator for the *Saturday Evening Post* at 22, Rockwell's climb was meteoric, and he did it on his own.

In the same way many of the characters in Rockwell paintings face their challenges singly. Look at the Scoutmaster charged with the responsibility of his sleeping troop (p. 112), the old cowboy (opposite) trying to recapture those yippie-eye-ay days, the pigtailed lass engaged in a hotly contested marbles shootout (p. 116), the boy attempting to screw up his courage on the high diving board (p. 116), the soaked fisherman who may have dreamed for months of this vacation (p. 117), or the train ticket seller (p. 118) who longs to take a trip to one of the places his customers are going—in all there is one common denominator: individuality.

Sometimes Rockwell's people are exuberant in expressing their individuality, like the case of the man who has shucked inhibition and gone for a swim (p. 119). That's Pop Zimmer of Arlington in the drink, incidentally. At other times Rockwell's subjects are unsure of themselves, searching, reflective, as in *Girl at the Mirror* (p. 120), the adolescent who seems to be asking whether or not she will ever be as beautiful as the movie star whose picture she holds in her lap. Though Rockwell seems to have more skill portraying young boys than girls, this effort (featuring a favorite Arlington model, Mary Whalen) is a winner on every count. The tossed-aside doll and the nearby comb, hairbrush, and cosmetics are the only props Rockwell needs to tell this slight but insightful story of growing up.

Many of Rockwell's characters evoke pathos—the traveling salesman playing solitaire in an off-the-beaten-track motel room (p. 121); the white-haired flutist, lost in a world of his own (p. 122); and a soul brother of the flutist, the man who is contemplating the purchase of a saxophone (p. 123) and the possibility of "jazzing up" his life.

There were times when Rockwell attempted to jazz up his life by changing his style of painting. For a period in the thirties, he tried to be more abstract, but his experiment proved a bust. Like the conservatively dressed man in the museum studying a modern art painting (p.124), Rockwell found it a foreign language and went back to what he did best.

And because he did, we have creations such as *Triple Self Portrait* (p. 125), which cleverly shows the artist three times over—from the back, in a mirror, and on his own canvas, the youngest and most handsome image of himself—the epitome of faith in one's self.

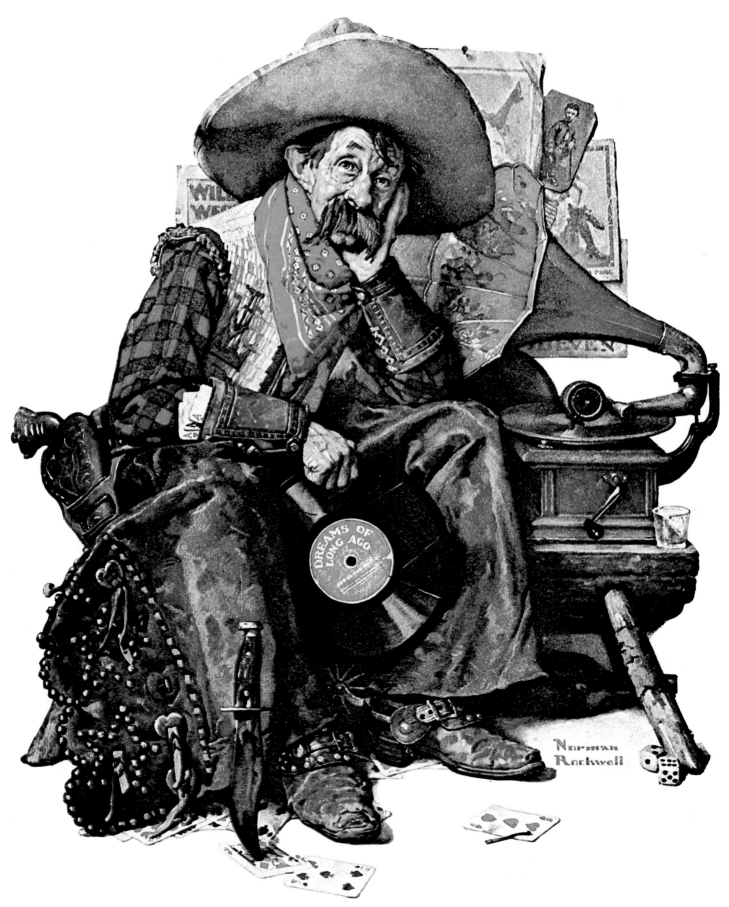

The Cowboy, *Post* cover, August 13, 1927

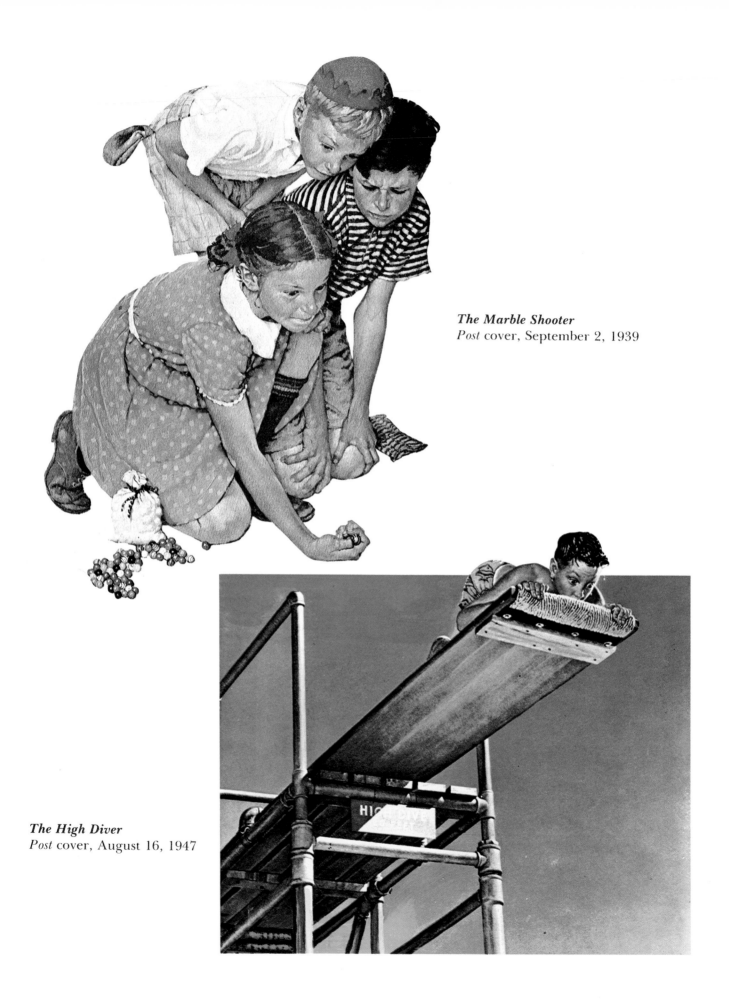

The Marble Shooter
Post cover, September 2, 1939

The High Diver
Post cover, August 16, 1947

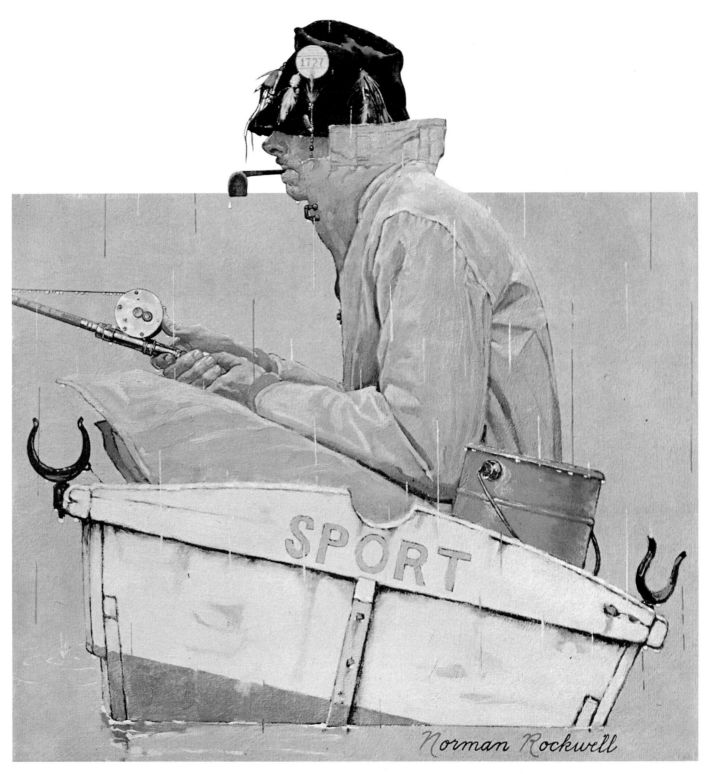

Fishing in the Rain, *Post* cover, April 29, 1939

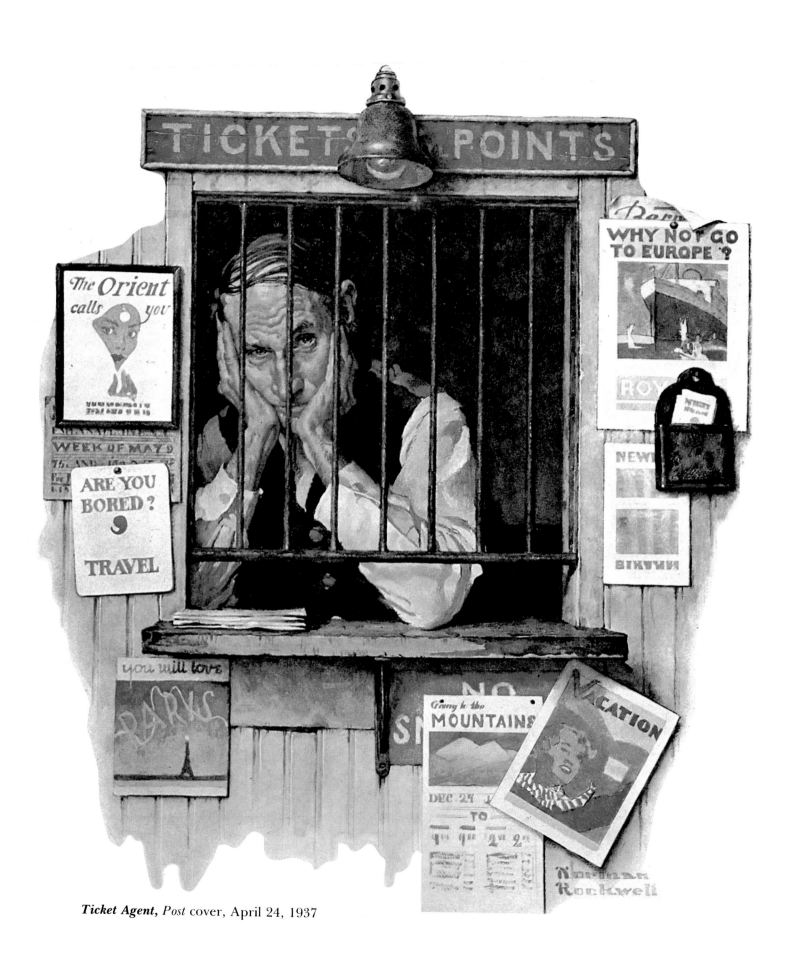

Ticket Agent, *Post* cover, April 24, 1937

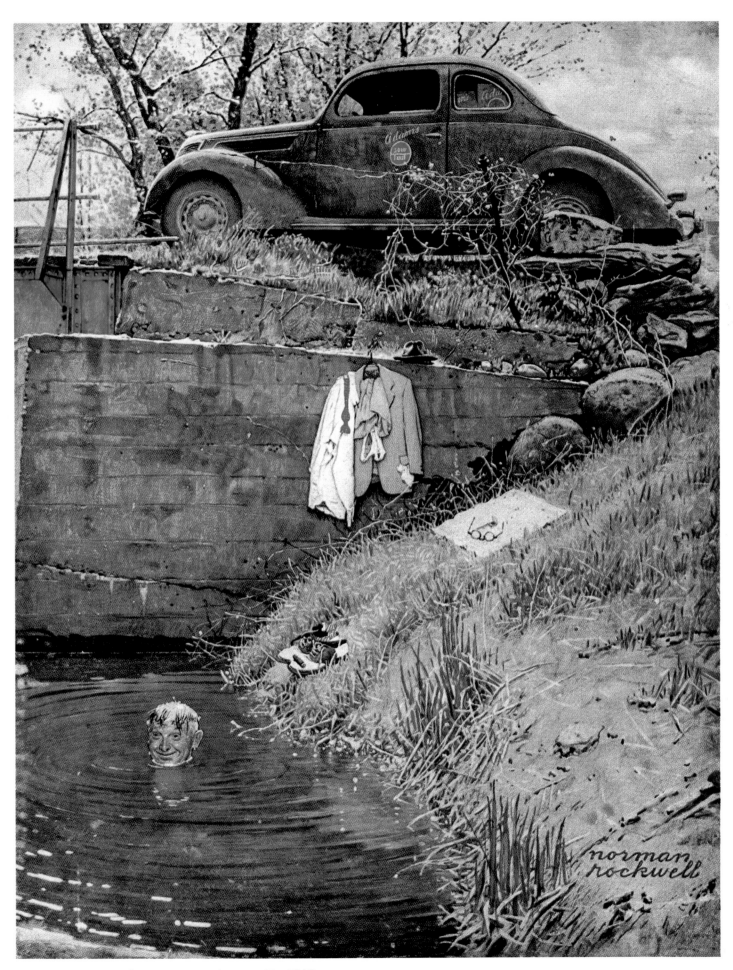

The Swimming Hole, *Post* cover, August 11, 1945

Girl at the Mirror, Post cover, March 6, 1954

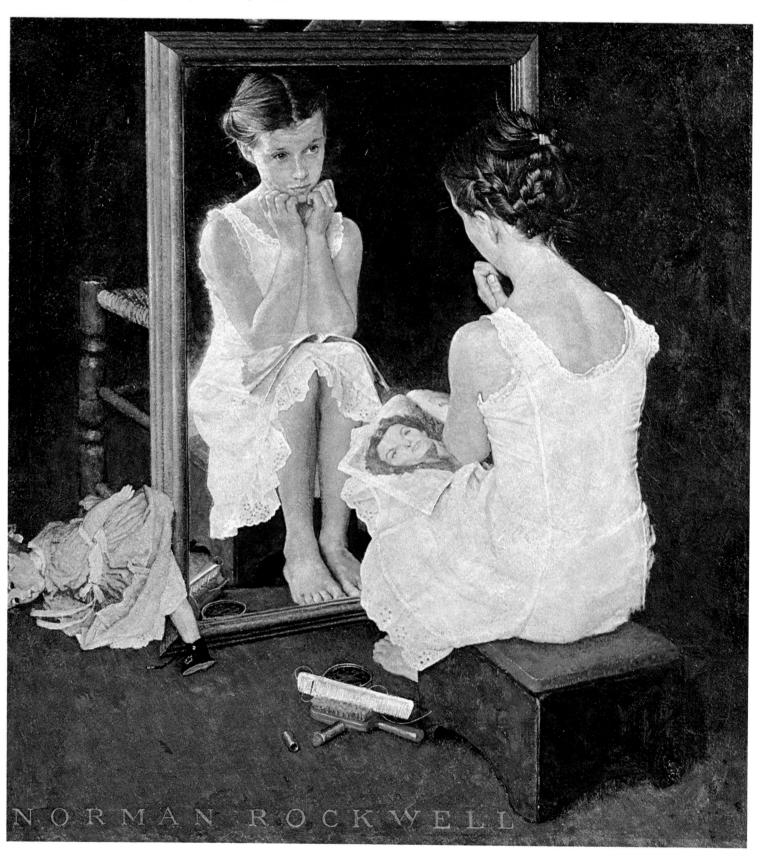

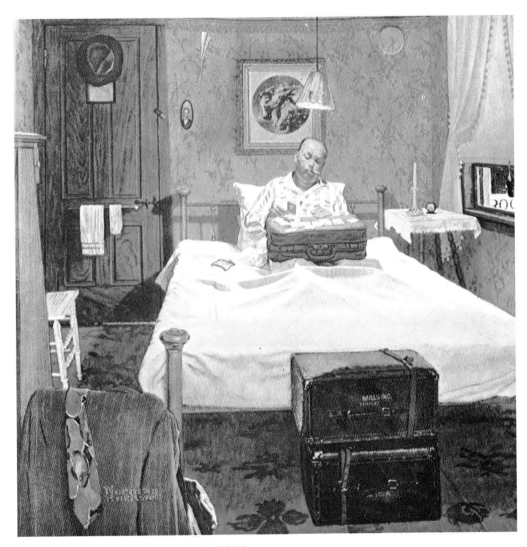

Solitaire, *Post* cover, August 19, 1950

Spring Song
Post cover, May 16, 1925

Jazz It Up, Post cover, November 2, 1929

Student of the Abstract, *Post* cover, January 13, 1962

Triple Self-Portrait, Post cover, February 13, 1960

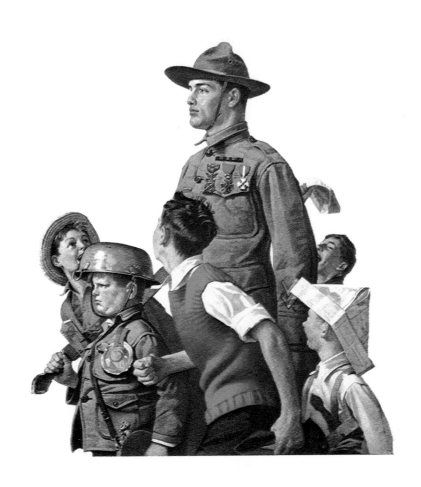

6. FAITH IN OUR COUNTRY

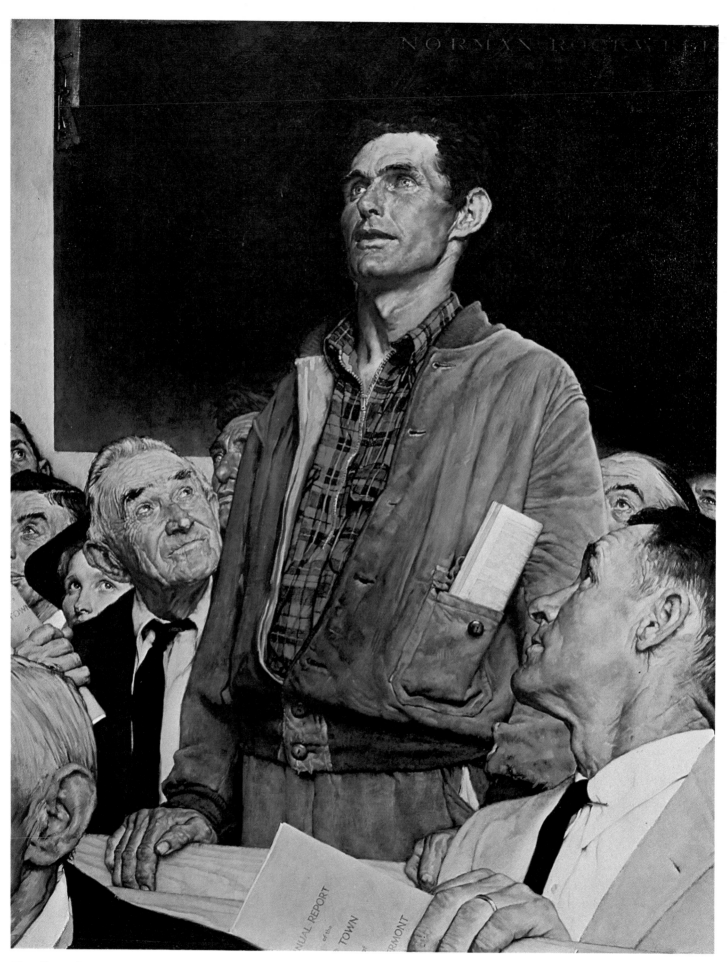

Freedom of Speech, 1943

Norman Rockwell, in his heyday, made Americans feel good about America. It wasn't very hard because then most Americans believed in America—wholeheartedly. For the majority it was, "My country—right or wrong." We knew we were the good guys and gals in white hats, and Rockwell showed us how fair we were by holding up a mirror and letting us ogle ourselves.

That was before the catharsis of the 1960s, when many people—inside and out of the country—told us how corrupt, deceitful, and degenerate we were. In retrospect, it is clear we were neither as pure nor as contaminated as either extreme would have had it.

The pendulum has swung back after some wild gyrations, and we are able to look objectively at ourselves once again. Rather than chastise Rockwell for not showing us ourselves, warts and all, we are able once again to appreciate the artist for what he was: a man who stressed the positive over the negative, our potential over our problems. What's more, he did it brilliantly.

One need only to tune in on Rockwell during World War II to see how effective he was. Wanting to do something for the war effort, he created the four *Freedoms*. His *Freedom of Speech* (opposite) is a masterful portrayal of democracy in action. Using a New England town meeting for his setting and an idealized young man (clean-cut Arlingtonian Carl Hess) for his model, Rockwell makes a resoundingly firm statement. It doesn't suggest that the man is a jingoist or patriotically patronizing; rather, he is a 20th-century American repeating an 18th-century battlecry: "Give me liberty or give me death."

Some say Rockwell was born to illustrate World War II. He certainly did it with great flair and imagination. Painting mostly from the home front, Rockwell drew Dad sitting anxiously by his radio following his son's progress in an illustration entitled *Armchair General* (above), as well as the son on Thanksgiving leave peeling potatoes in the kitchen (opposite) while his proud Mom looks on.

When the war was over, Rockwell reported America's happy homecoming celebrations. One of his most popular reunions depicts a soldier returning to an arms-open-wide Mom and the rest of his jubilant family and friends who live in the same apartment building

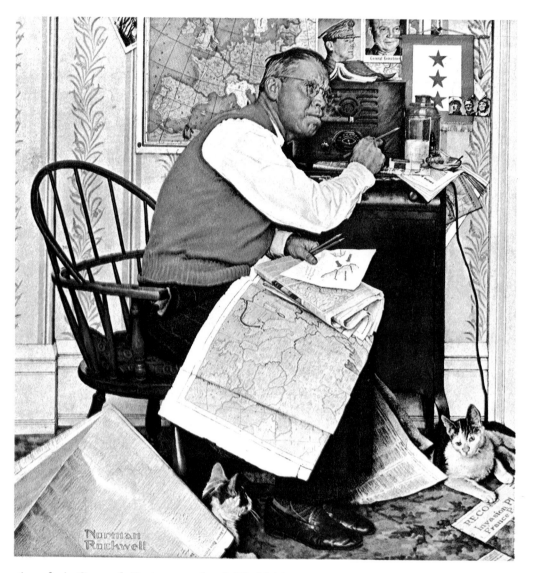

Armchair General, *Post* cover, April 29, 1944

(p. 132). Other blue-starred window banners in the painting suggest that other conquering heroes are yet to return. It is interesting to observe that there are no gold stars on display. Also, in one of Rockwell's frequent subplots, note the young girl with her back to the wall at the far left. She could be merely a supernumerary, but with Rockwell at the controls there is the subtle suggestion that she has grown up during the war and a romance may be in the offing.

Another favorite Rockwell postwar painting is *The War Hero* (p. 133), which was set in Bob Benedict's Arlington garage. Featured were Bob behind the Marine; Nip Noyes, Arlington's town clerk, as the policeman; Jerry Rockwell, the older boy; and Peter Rockwell, sitting next to the much-decorated serviceman.

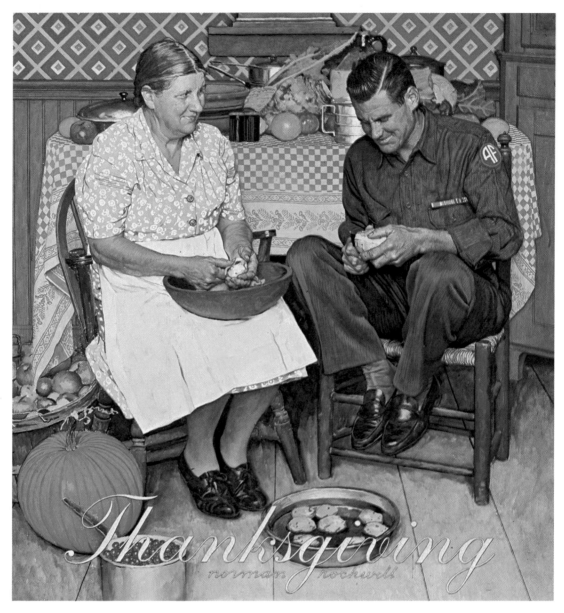

Thanksgiving, Post cover, November 24, 1945

But it wasn't long before it was "business as usual." Willie Gillis, Rockwell's star performer in many World War II illustrations, struggled into outgrown civilian clothes (p. 134) and went off to college (p. 135). Commuters went back to their trains (p. 136).

And the processes of democracy went on. There were juries on which to serve—and positions to be taken, even if one were in the minority (above). And elections to be held.

Rockwell's famous exhausted-and-defeated politician, the mythical Mr. Casey (p. 138), reminds us that in politics at least half the candidates get to wait 'til next time. From 1956 forward, Rockwell was called upon to paint both the Republican and the Democratic candidates for the Presidency; he seemed as nonpartisan in his portrayal of

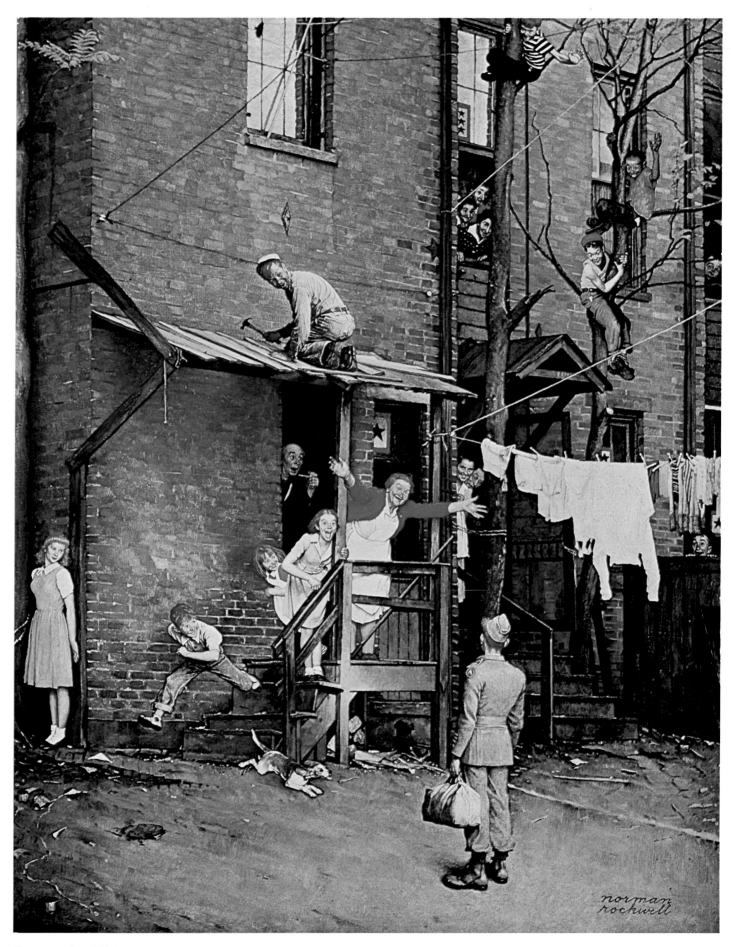

Homecoming GI, *Post* cover, May 26, 1945

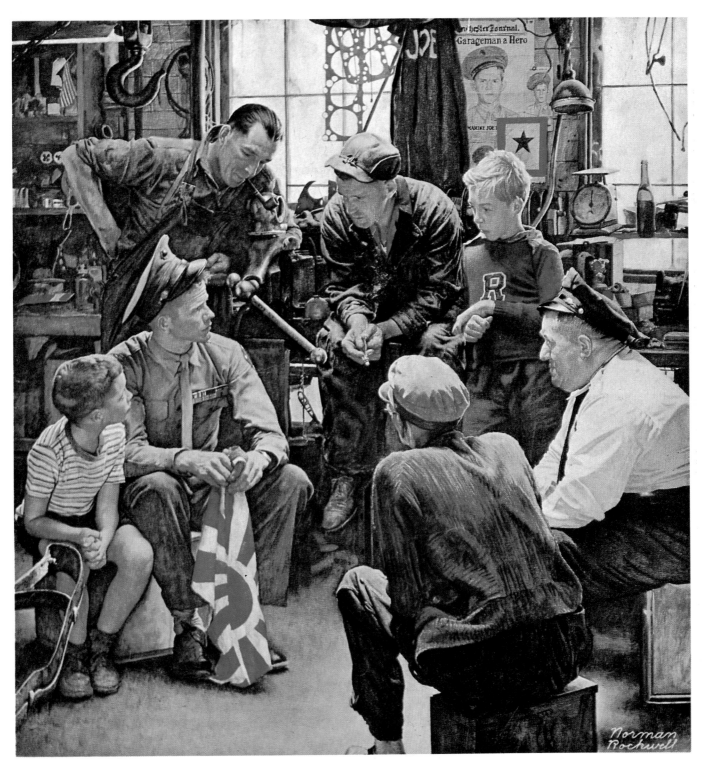

War Hero, *Post* cover, October 13, 1945

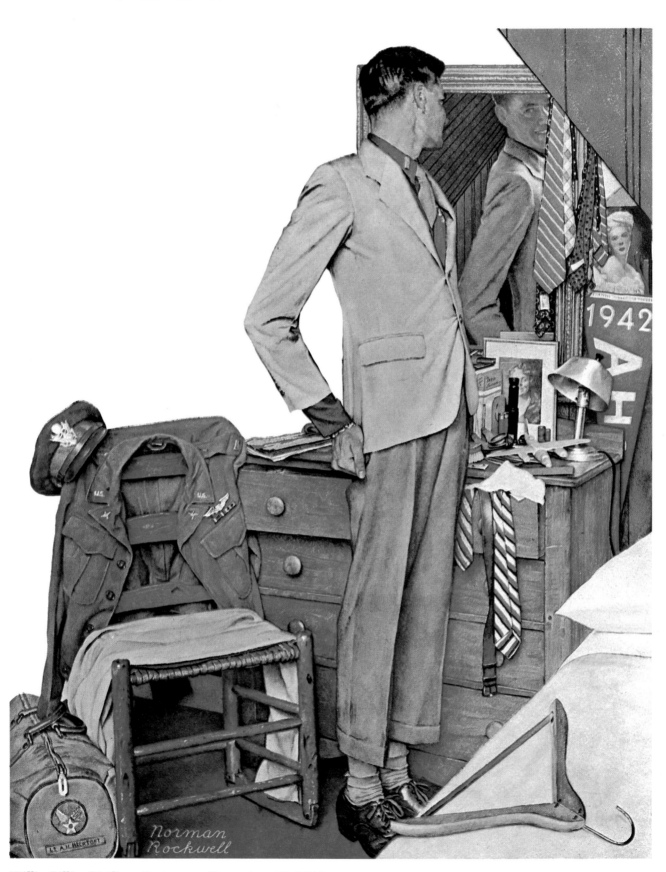

Willie Gillis, Civilian, *Post* cover, December 15, 1945

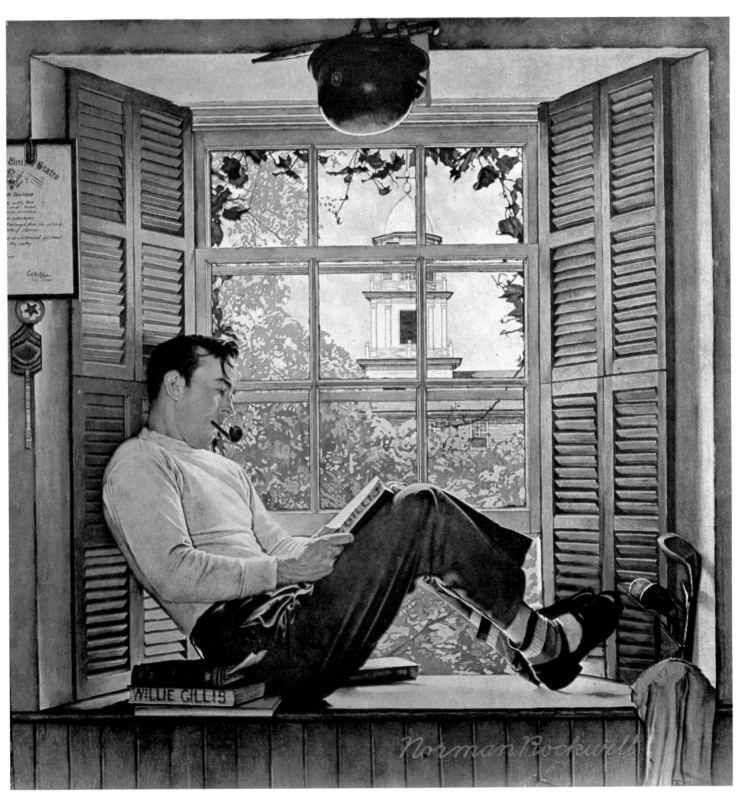

Willie Gillis Goes to College, *Post* cover, October 5, 1946

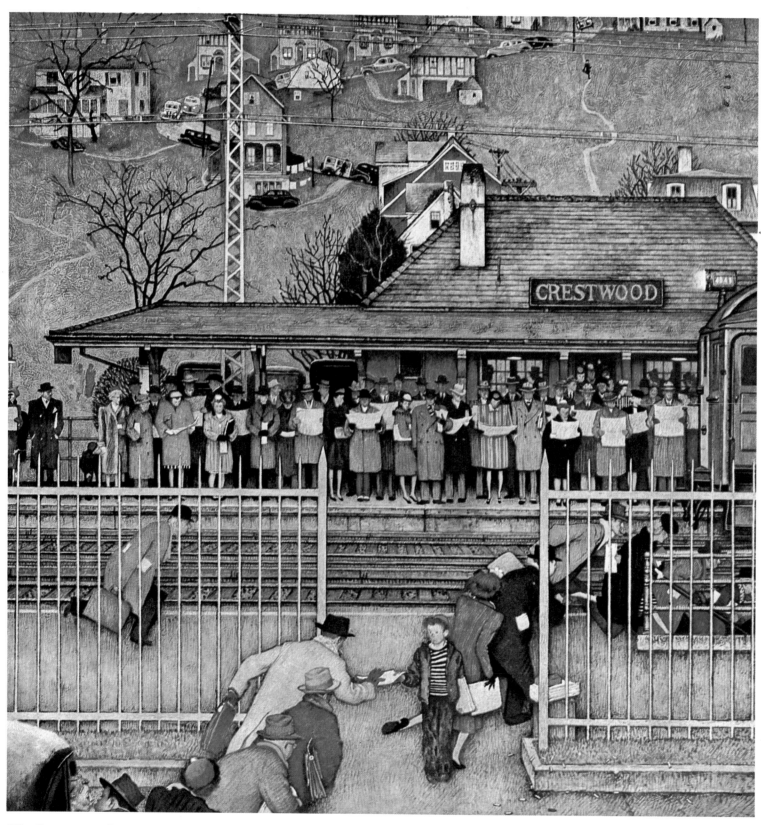

The Commuters, Post cover, November 16, 1946

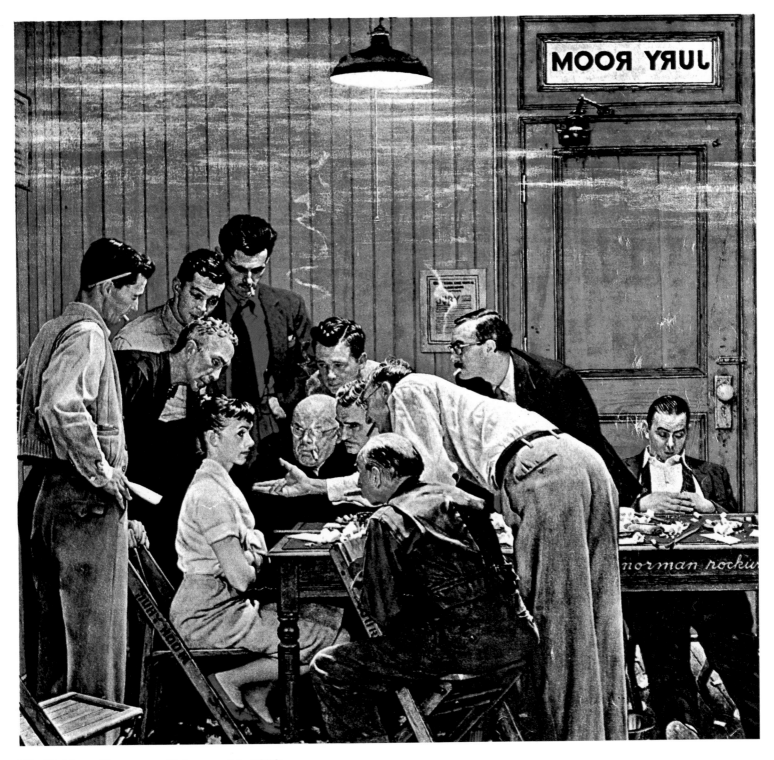

The Holdout, *Post* cover, February 14, 1959

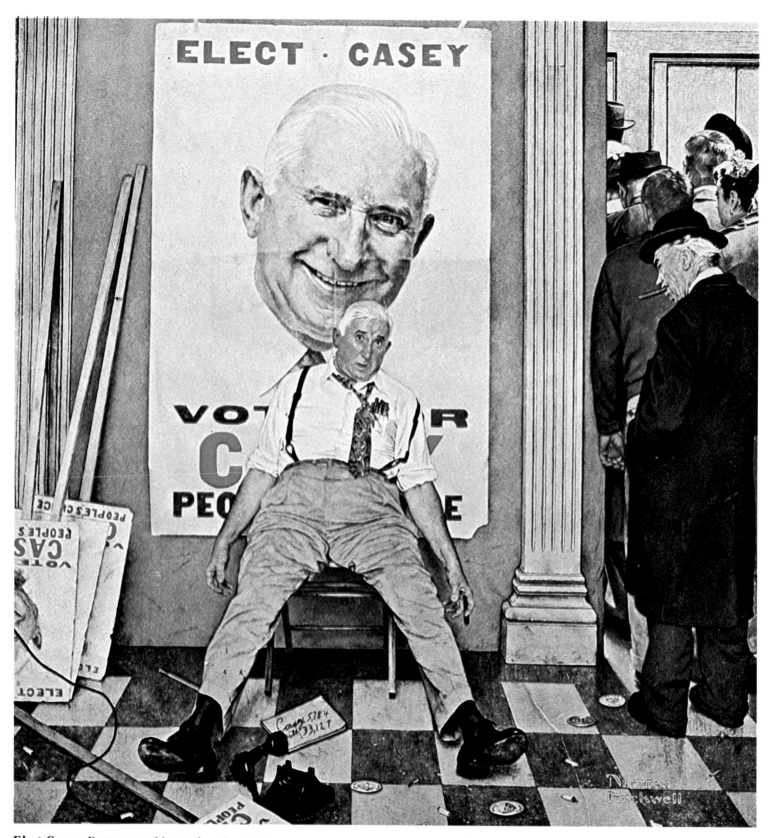

Elect Casey, *Post* cover, November 8, 1958

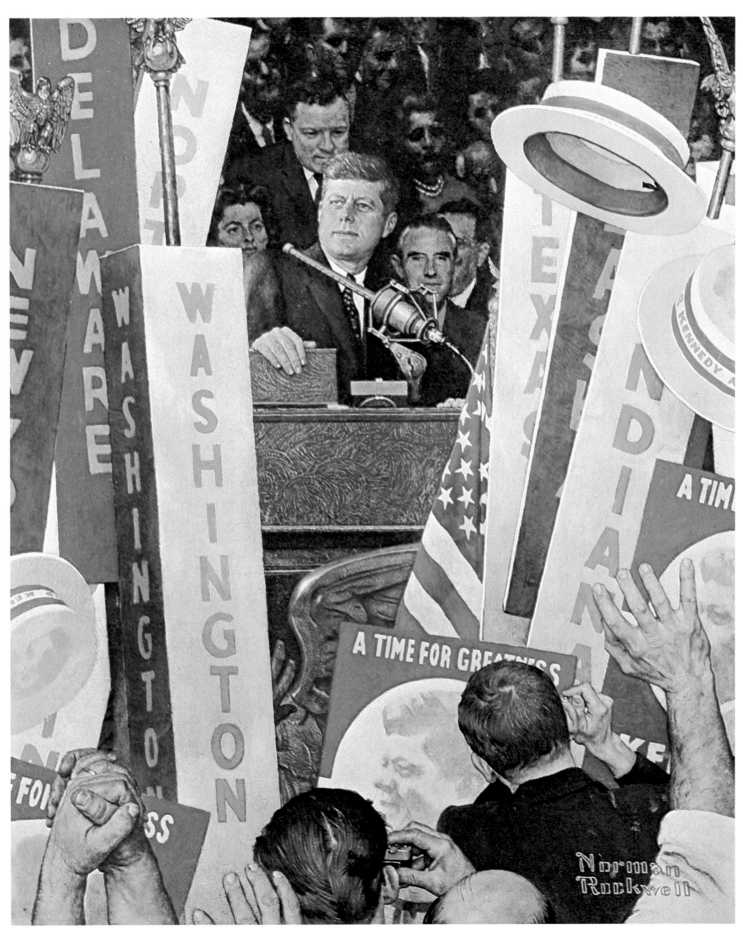

A Time for Greatness, Look cover, July 14, 1964

Eisenhower, *Post* cover, October 13, 1956

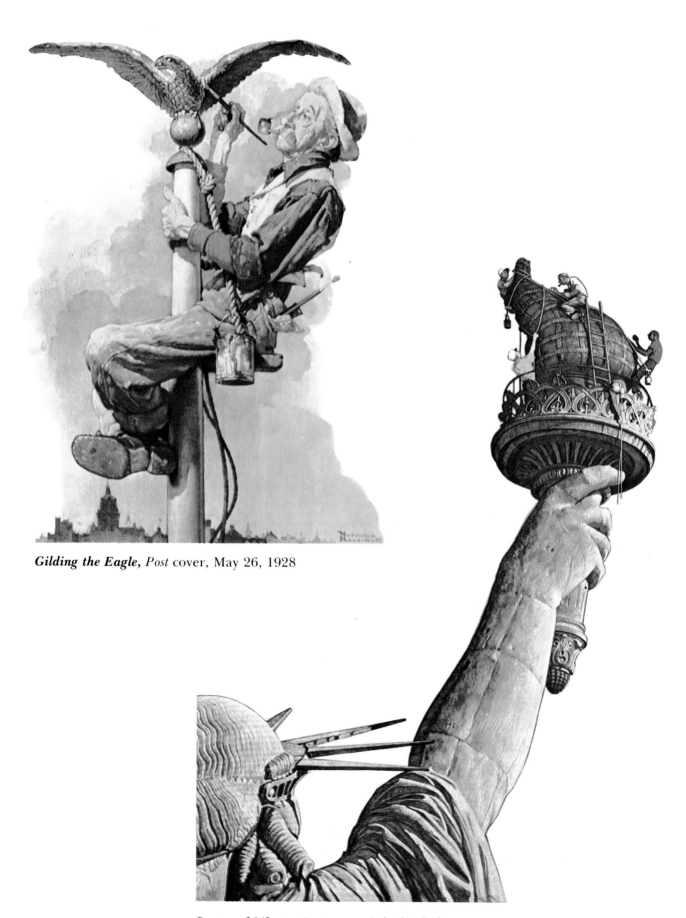

Gilding the Eagle, *Post* cover, May 26, 1928

Statue of Liberty, *Post* cover, July 6, 1946

Pittsfield Main Street, Berkshire Life Insurance Company, 1963

one man as the other. Cases in point: Rockwell's 1956 painting of a warm-eyed Eisenhower (p. 140) and his 1964 illustration of Kennedy accepting the nomination (p. 139).

Meanwhile, the job of maintaining a republic requires continual attention, like that of the men cleaning the Statue of Liberty's torch (p. 141) and the aging painter refurbishing an aging eagle atop a flagpole. (The model is a Rockwell regular, James K. Van Brunt.)

Finally, what would a country be without parades (above)? This one is set in Pittsfield, Massachusetts, in the year 1851, according to the date on the hot-air balloon. It appears to be quite a celebration, with the whole town turned out.

I suppose we all have our childhood memories of Fourth of July parades. Mine center on a little community in northwest Ohio, the backdrop for this recollection:

The big parade always formed at the town hall. There, freshly polished fire engines gleamed apple red under a breathtakingly cloudless sky. Kids on bikes decorated with red, white, and blue crepe

142

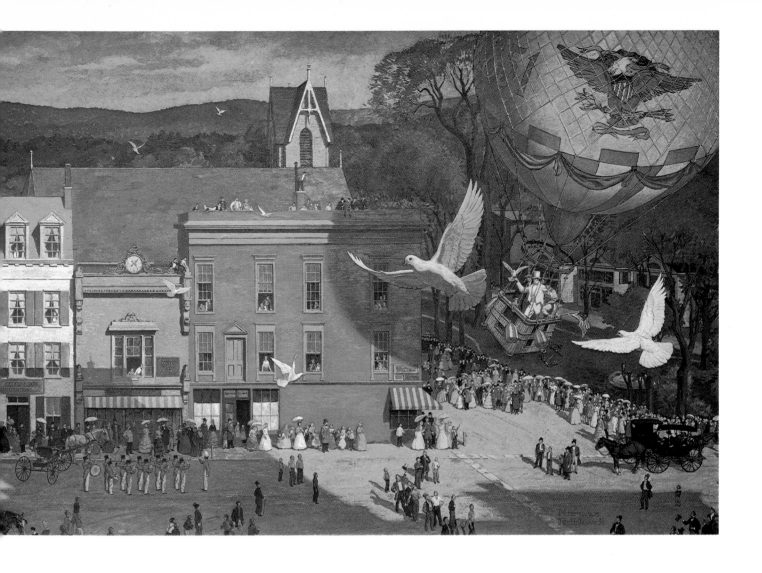

paper rode dizzying figure-eights around the cordoned street. Drum majorettes in spotless white boots with red tassels practiced twirling their batons, and the reflection off those silvery sticks danced merrily across faces in the crowds. The crowd held no strangers, just mothers, dads, grandparents, aunts, and uncles who always came downtown to watch. The horsemen, astride their well-brushed steeds, stood at attention and so did the gray-haired men in military uniforms that had been cut for more svelte physiques than the ones they now strained to cover. I always started early enough, right after lunch, to be there when the police chief turned on his flashing light and led the marchers up Main Street toward the high school, but I had to cross Cranberry Run and it had a special magic, too. Sunning turtles and darting tadpoles could steal my mind in a minute. Only the sound of a band in the distance, striking up some heartstopping march like "Stars and Stripes Forever," would remind me of the celebration. Then, I'd run for blocks to bring up the rear of the big parade.

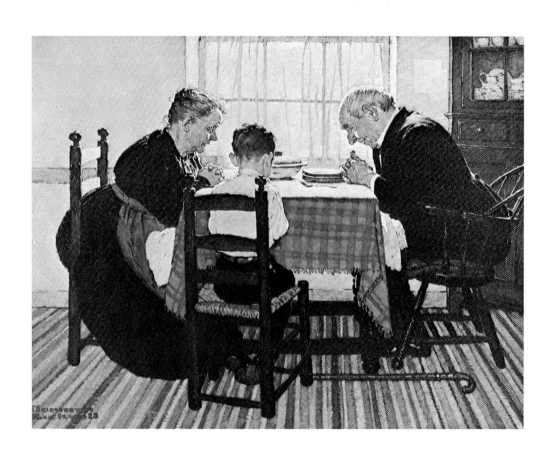

7. FAITH IN OUR GOD

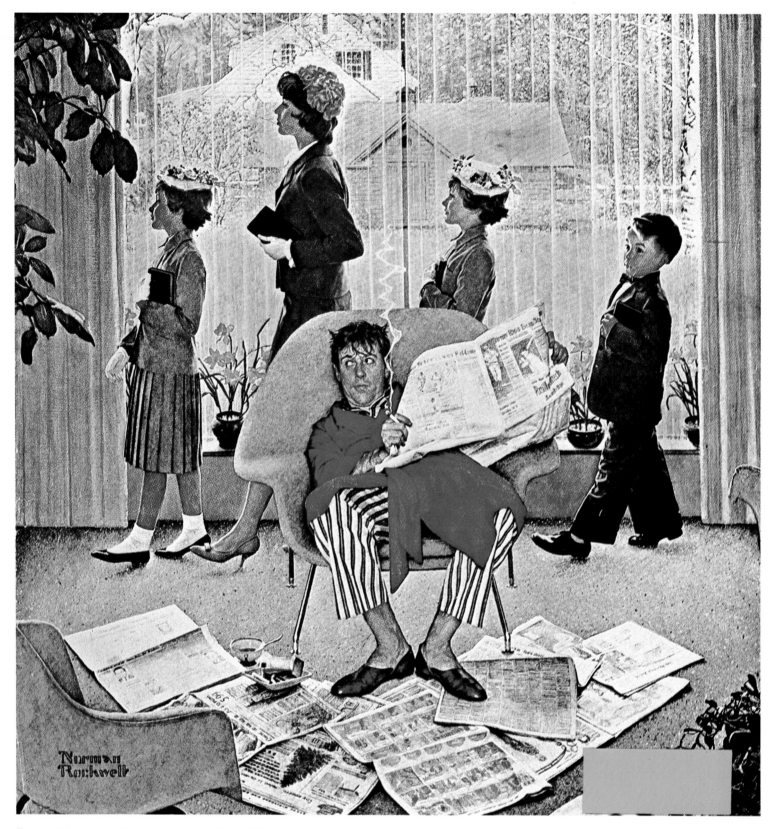

Easter Morning, Post cover, May 16, 1959

Early in this book I suggested that the Bible verse that says faith is the substance of things hoped for, the evidence of things not seen, just about sums up Norman Rockwell's philosophy of life. After finishing my research on the man and his work, I believe his theology can be capsuled by another Bible verse that advises God's people "to do justly, and to love mercy and to walk humbly with thy God" (Micah 6:8). To study Rockwell's life and conclude that he was anything but fair, merciful, and humble is a misreading of the man.

Born into a strict Christian home ("We weren't allowed to play with toys or read funny papers on Sunday," he wrote), Rockwell spent several years as a choirboy in New York at St. Luke's and at the Cathedral of St. John the Divine ("We rehearsed four times a week and sang at four Sunday services"). Later in life, Rockwell recalled how mischievous he and some other members of a Mamaroneck church choir had been—reaching through the latticework of the choir rail to pull on the knickers or dresses of friends who had come forward for confirmation.

Many of his illustrations that have a religious flavor, theme, or setting incorporate this same playfulness. Here is more evidence that Rockwell was a kid, first, last and always. It was hard for him to paint angelic piety on the faces of devilish Tom Sawyers who had been caught elbow-deep in figurative cookie jars. Examples abound: the painting of the pajama-clad father slouching in his chair, trying to avoid the icy stare of his Easter-service-bound wife and her well-turned-out brood (opposite); the one of the family walking to church past the doorsteps of unrepentant sleepers, judging from tattletale milk bottles and uncollected Sunday newspapers (p. 152); and the illustration of the sidewalk-gazing pedestrians who are too absorbed in earthly matters to heed the "uplifting" spiritual admonition on the church signboard (p. 151).

Possibly because of his own experiences as a choir boy, Rockwell seems to have an eternal warm spot in his heart for those young men who are called upon temporarily to forsake noisy baseball diamonds and dusty play clothes for dignified church services and starchy white-collared robes. His illustration of a youngster fighting a recalci-

trant cowlick just prior to the processional (opposite) seems typical of the Rockwell approach.

This painting reminds me that I once wrote about a stuttering choir boy for a Christmas greeting that was illustrated by Rockwell. It went like this:

Everyone was surprised—everyone except Mrs. Brown, the choir director—when Herbie showed up in November to rehearse for the church's annual Christmas cantata.

Mrs. Brown wasn't surprised because she had persuaded Herbie to "at least try." That was an accomplishment, for lately he had quit trying nearly everything—reciting in class, playing ball or even asking his brothers or sisters to pass the potatoes.

It was easy to understand: he stuttered. Not just a little, either, and sometimes when his tongue spun on a word, like a car on ice, kids laughed. Not a big ha-ha laugh, but you can tell when people are laughing at you even if you're only nine.

Mrs. Brown had figured Herbie would sing with the tenors—Charley and Billy—and not have any trouble, which is exactly the way it worked. Billy was given the only boy's solo and the rest of the time the three of them sang in unison, until Charley contracted the measles. Even so, Billy had a strong voice and Herbie knew he could follow him.

At 7:15 the night of the cantata, a scrubbed and combed Herbie arrived at church, wearing a white shirt, a new blue and yellow bow tie and his only suit, a brown one with high-water pant legs. Mrs. Brown was waiting for him at the door.

"Billy is home in bed with the flu," she said. "You'll have to sing solo." Herbie's thin face grew pale.

"I c-c-can't," he answered.

"We need you," Mrs. Brown insisted.

It was unfair. He wouldn't do it. She couldn't make him. All of these thoughts tumbled through Herbie's mind until Mrs. Brown told him this:

"Herbie, I know you can do this—with God's help. Across from the choir loft is a stained-glass window showing the manger scene. When you sing solo, I want you to sing it only to the Baby Jesus. Forget that there is anyone else present. Don't even glance at the audience." She looked at her watch. It was time for the program to begin.

"Will you do it?"

Herbie studied his shoes.

"I'll t-t-try," he finally answered in a whisper.

148

The Choirboy, *Post* cover, April 17, 1954

A long 20 minutes later, it came time for Herbie's solo. Intently, he studied the stained-glass window. Mrs. Brown nodded, and he opened his mouth, but at that exact instant someone in the congregation coughed.

"H-H-Hallelujah," he stammered. Mrs. Brown stopped playing and started over. Again, Herbie fixed his eyes on the Christ Child. Again, he sang.

"Hallelujah, the Lord is born," his voice rang out, clear and confident. And the rest of his solo was just as perfect.

After the program, Herbie slipped into his coat and darted out a back door—so fast that Mrs. Brown had to run to catch him. From the top of the steps, she called, "Herbie, you were wonderful. Merry Christmas."

"Merry Christmas to you, Mrs. Brown," he shouted back. Then, turning, he raced off into the night through ankle-deep snow—without boots. But then he didn't really need them. His feet weren't touching the ground.

Of course, Rockwell could and did deal seriously with religious subjects when the situation demanded. His on-leave soldier, Willie Gillis, sitting in a church pew (p. 153) was painted mid-war, and there is no levity in Willie's face. And his painting *The Golden Rule* (p. 155) speaks to the universality of faith in God with prayerful reverence, as does *Our Heritage* (p. 154), which portrays a petitioning General Washington at Valley Forge, and *Son of David* (pp. 156–57), the previously mentioned illustration, which hangs in the Stockbridge museum.

But the *pièces de résistance* in the religious category are Rockwell's deeply moving *Freedom of Worship* (p. 159), which is sweeping in the spiritual ground it covers, and *Saying Grace* (p. 159), powerful because of its simplicity, gripping because of its honesty and dignity.

Ken Stuart, who was Rockwell's art editor for many years at the *Post*, recalls some interesting particulars about the latter painting. First of all, he saw such a scene himself one Sunday at a Philadelphia automat, where he had taken two of his children and their friends following a concert. At the next table, he noticed an Amish family saying grace. Other than calling his group's attention to the fact that some people always ask God to bless their food before eating—even in restaurants—Ken forgot the occurrence until Rockwell submitted a painting that pictured such an episode a few weeks later. Expressing amazement, Ken told Rockwell of his coincidental experience. Rockwell explained that he had gotten the idea from a woman who had written him. Apparently, she had been present in the Philadelphia restaurant at the same time! Rockwell's only alteration: he chose to show

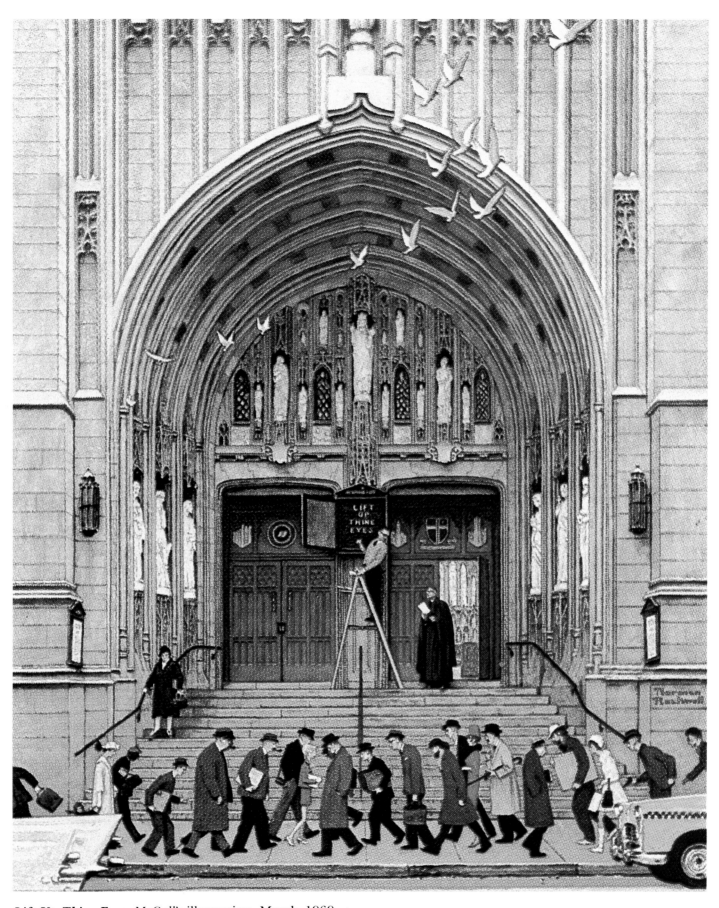

Lift Up Thine Eyes, *McCall's* illustration, March 1969

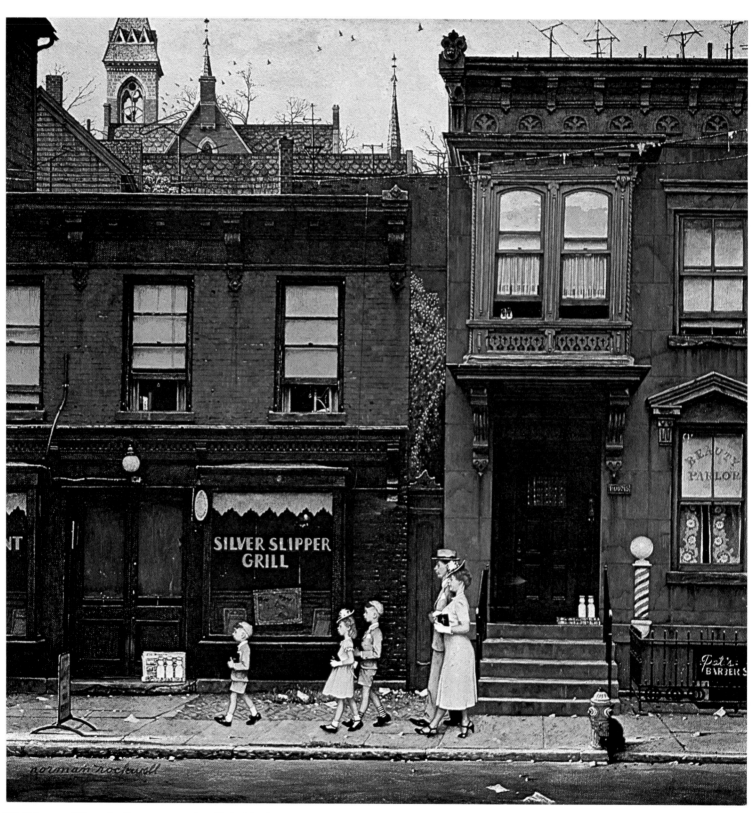

Walking to Church, *Post* cover, April 4, 1953

152

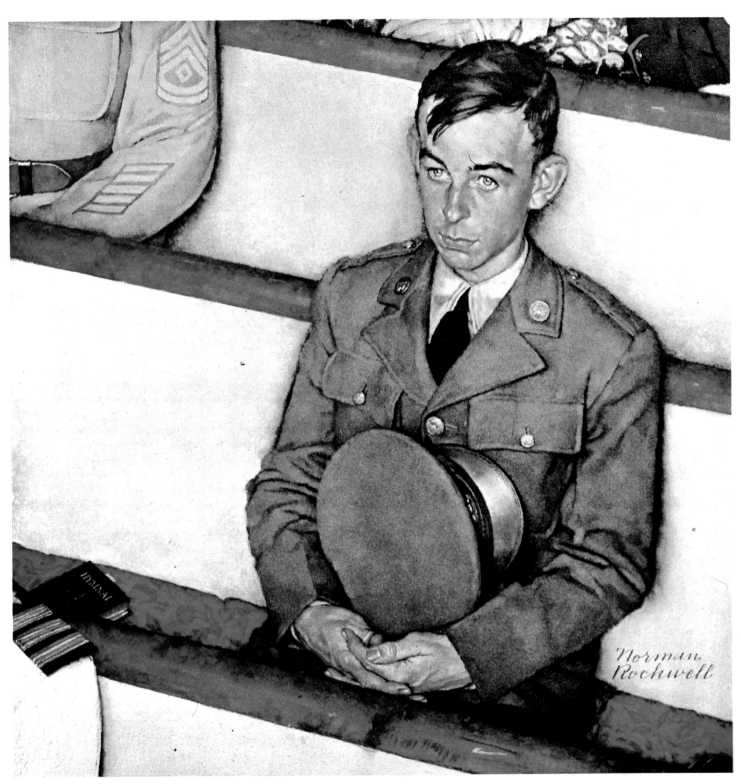

Willie Gillis in Church, *Post* cover, July 25, 1942

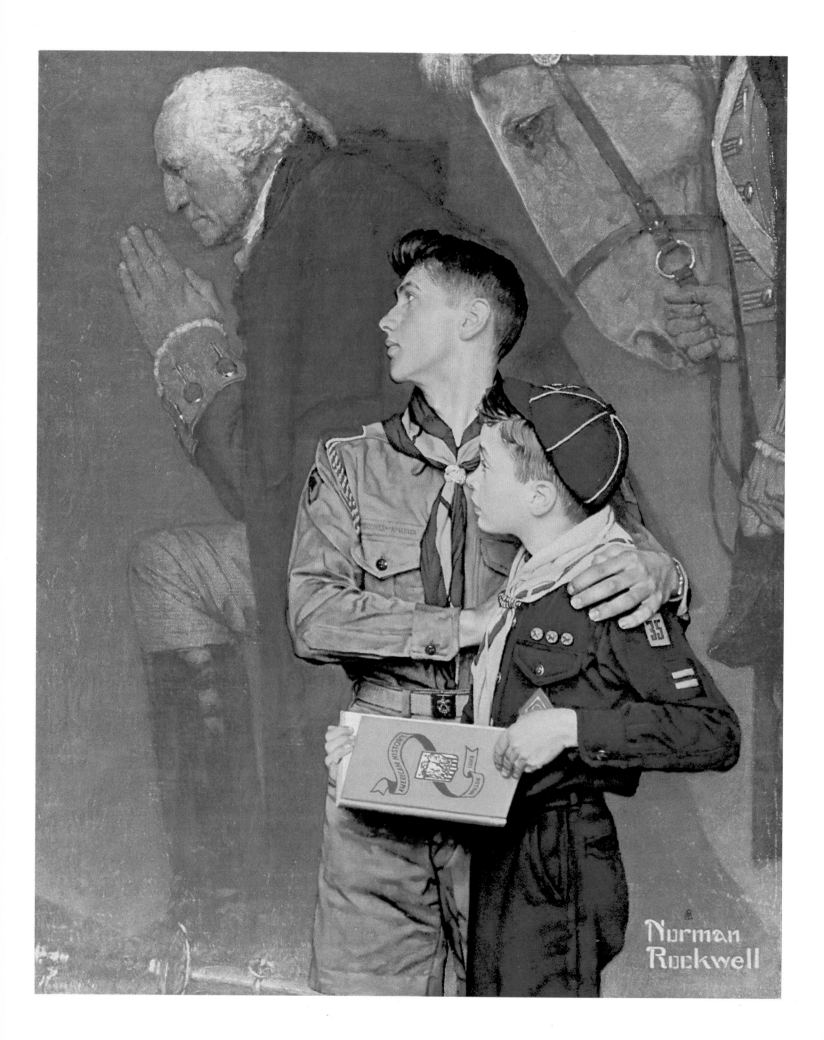

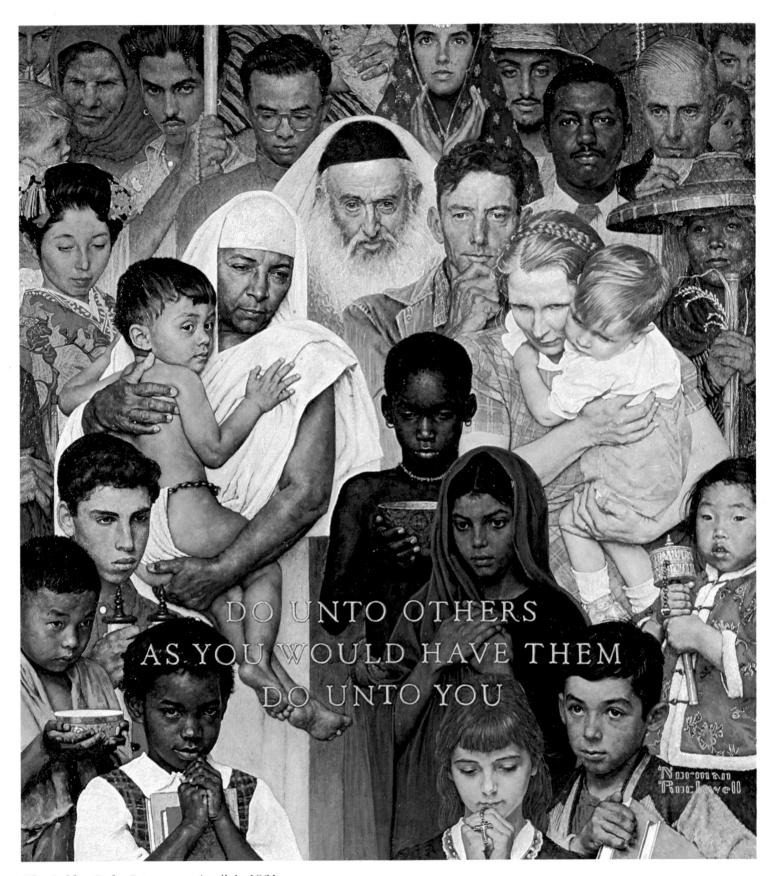

DO UNTO OTHERS
AS YOU WOULD HAVE THEM
DO UNTO YOU

The Golden Rule, Post cover, April 1, 1961

Son of David (Adoration of the Magi),
Woman's Home Companion illustration, 1941

a grandmother and grandson praying instead of an Amish family.

Little wonder it is Ken Stuart's favorite (Rockwell made him a present of the original) or that it is the all-time favorite illustration of *Saturday Evening Post* readers. The fact that it is so popular may shed some light on the kind of people we admire—and really at heart long to be like.

When I think of "shedding light," Rockwell's painting of the workman repairing the church's stained-glass window comes to mind (p. 160). Characteristically, Rockwell would not settle for an ordinary

156

laborer, but posed a real stained-glass craftsman. The colorful window features some saintlike creatures flying ethereally in space.

Once, according to an old story, a teacher of catechism inquired of his students, "Who are the saints?"

Turning toward the church's sun-filtering windows, which memorialized the church's holiest men and women, a young innocent responded, "They're the people that the light shines through."

Rockwell was no saint, but through his work he gave us light— light to see ourselves more clearly and those about us more dearly.

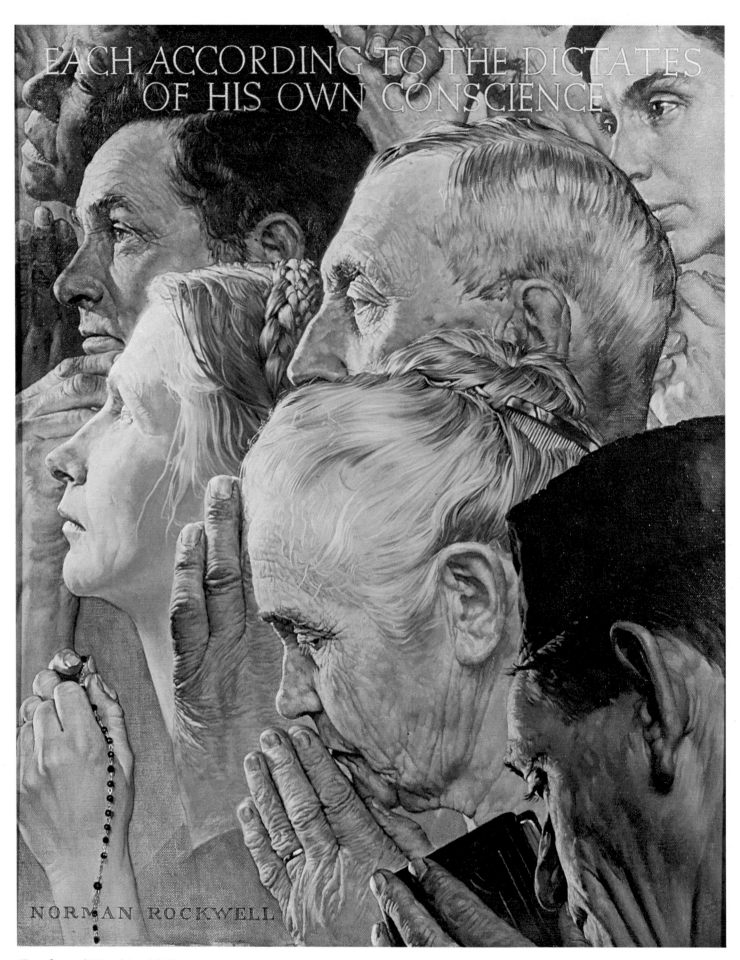

Freedom of Worship, 1943

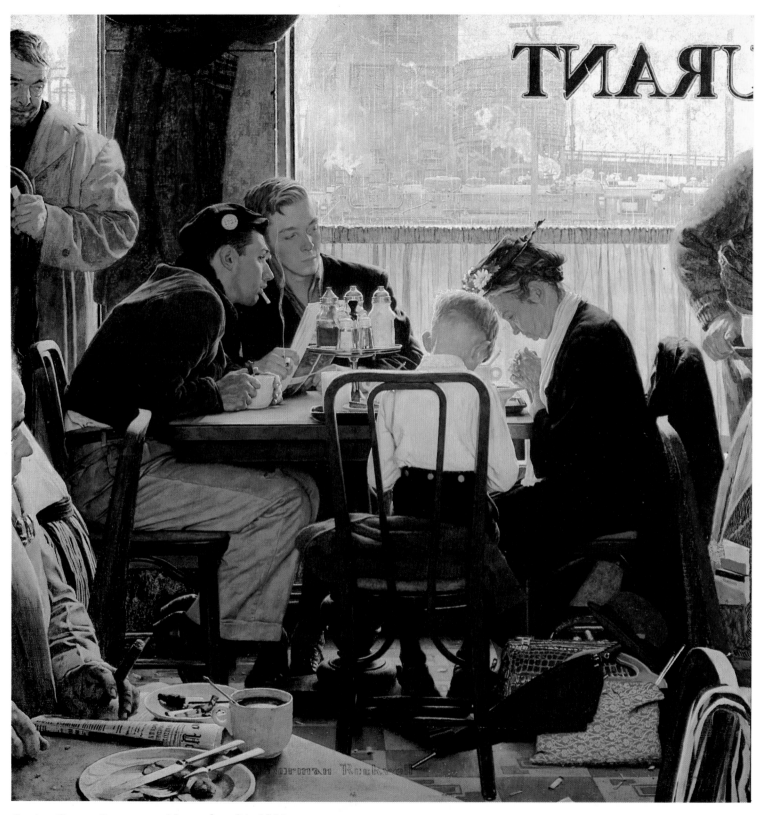

Saying Grace, *Post* cover, November 24, 1951

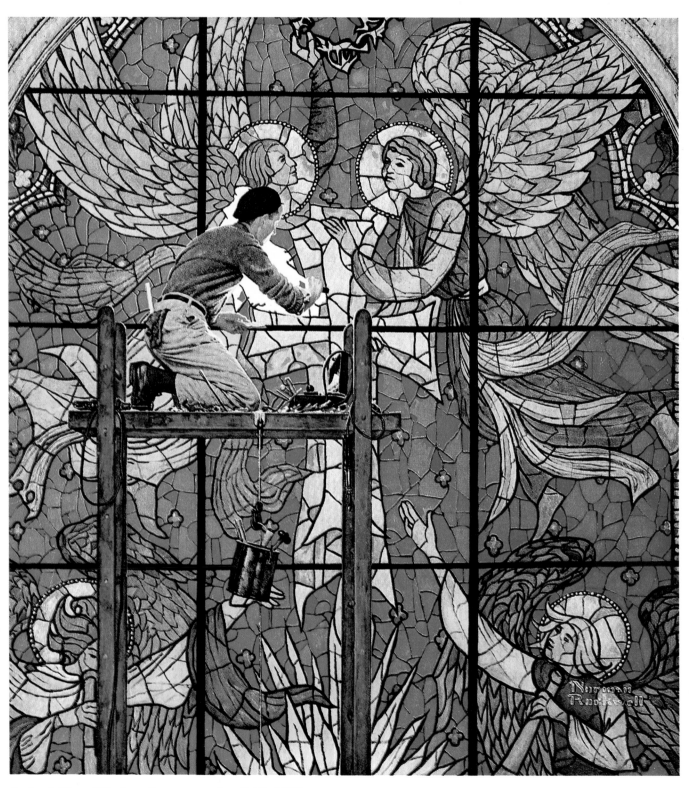

Stained Glass Window, *Post* cover, April 16, 1960